A Map of My Heart

The forests of baking cakes for you that always get burned.

The Heights of thinking about you every day...

THE ROAD TO YOU

The Lakes of lazy afternoons Laughing with you

the Oceans of starlit skinny dipping & fires on the beach.

The Plains of freshly brewed coffee in the morning.

The Mountains of late nights, loud singing, and too much red wine.

THE RIVER OF LOVE

HOW TO MAKE

HAND-DRAWN

MAPS

HELEN CANN

A CREATIVE GUIDE

WITH TIPS, TRICKS, AND PROJECTS

CHRONICLE BOOKS

SAN FRANCISCO

First published in the United States of America in 2018 by Chronicle Books LLC.

First published in the United Kingdom in 2017 by Thames & Hudson Ltd.

© 2018 Quarto Publishing plc

Conceived, Designed and Produced by Quid Publishing, an imprint of The Quarto Group

The Old Brewery, 6 Blundell Street,
London N7 9BH, United Kingdom
T (0) 20 7700 6700 F (0) 20 7700 8066

www.QuartoKnows.com

ISBN: 978-1-4521-6991-0

Manufactured in China

10 9 8 7 6 5 4 3 2

Chronicle books and gifts are available at special quantity discounts to corporations, professional associations, literacy programs, and other organizations. For details and discount information, please contact our premiums department at corporatesales@chroniclebooks.com or at 1-800-759-0190.

Chronicle Books LLC
680 Second Street
San Francisco, California 94107

www.chroniclebooks.com

CONTENTS

6

INTRODUCTION

7

ABOUT
THIS BOOK

8

A BRIEF HISTORY
OF MAPS

10

SECTION 1
MAP ANATOMY

38

SECTION 2
TYPES OF MAP

66

SECTION 3
MAPS OF PLACES

94

SECTION 4
MAPS OF IDEAS

130

SECTION 5
PROJECTS

158

INDEX

160

ABOUT
THE AUTHOR

161

TEMPLATES

INTRODUCTION

Open a traditional paper map and mysteries await. The labyrinthine folds and arcane symbols reveal so much more information than any GPS could. They provide a broad bird's-eye view, not only of the geography, but also the culture and history of a place. Comparing a traditional map to a GPS map is like comparing the view from a mountaintop to the view through a tunnel. A GPS map can tell you nothing of the historical idiosyncrasies of its respective cultures or creators, nor can it show the patterns of towns as they grew from an ancient tangle of dwellings to huge urban grids.

My own journey through the history of hand-drawn maps began with an ill-fated job in a gallery selling antique prints (I lasted three weeks). I became fascinated by the crude colors and intriguing details left by the great 17th-century cartographers John Speed and John Ogilby. Their personalities ring out clearly from their work. Hand-drawn, their maps depict features they considered important, with the rest left out. A cartographer always makes maps for a reason—to show boundaries, to display ownership and wealth, to keep people out, or things in, or simply to document. The details we see on maps are the result of this process, presented in a perfect combination of information and design.

ABOUT THIS BOOK

In this book you will learn how to draw basic maps in your own personal way. You will discover how to create compass roses, cartouches, and symbols— the basic tools you need to become a mapmaker. Then, we will look at different ways to present a 3-D landscape on a 2-D plane—from architectural blueprints to subway maps, axonometric grids to treasure maps. We will move on from geographical regions to look at mapping concepts— charting thought processes, families, and anatomy.

Each chapter has an exercise for you to try yourself. Sometimes these might involve having to do some research. You might have to get outside for a walk. Some exercises need graph paper or require premade templates, which you can find at the back of this book.

You will, of course, need something to draw with. Every map in this book starts with a simple line drawing, but often in my examples I have incorporated color. Feel free to experiment with different materials in your own creations. A couple of exercises recommend the use of compasses, rulers, and protractors, but since these are hand-drawn maps, and not exercises in technical precision, these can also be done by eye.

The last chapter suggests a number of simple ways in which you can incorporate hand-drawn maps into practical projects. Hand-drawn maps are a perfect means of providing directions, remembering your travels, or simply expressing yourself.

Among my own examples you will find mentions of other noteworthy cartographic artworks for you to research. As further inspiration, there are profiles of five international cartographic artists. Creating hand-drawn maps is in itself a personal journey, so let your personality shine through. When producing your own maps, highlight the features that matter to you. Whether you're mapping a real or an imagined landscape, map your world in your way.

A BRIEF HISTORY
OF MAPS

The art of mapping has a long and rich history. Maps have been a vital part of communication from the moment people wanted to describe to each other the details of a place, or show how to get somewhere. Examples of early mapmaking abound. Stone Age maps of the constellations are daubed on cave walls in France. Beautiful wood-carved maps from Inuit Greenland show the formations of the coastline. These tiny, tactile map sculptures would have fitted neatly into a sealskin pocket and been useful on any hunting expedition. Polynesian seafarers who settled the Pacific made maps of the seas with sticks, shells, and palm fronds, all tied together. Obviously, there is a strong need to visually describe places.

As civilizations grew and developed, mapping techniques became more refined. The ancient Babylonians created clay tablets impressed with symbols for mountains, rivers, and cities. The Egyptians drew maps on papyrus showing the boundaries of land allotments around the River Nile. The ancient Greek polymath, Ptolemy, imposed mathematical rules on his mapmaking. In around AD 150 he published *Geographia*, a treatise on cartography, with maps showing the coordinates for latitude and longitude. His system revolutionized thinking on geography and had a continued influence on academics well into the Renaissance period.

In Europe during the Middle Ages, maps were mainly produced within monasteries. ,Religion was at the heart of these illuminated and gilded medieval maps. Pilgrimage routes to Jerusalem were documented in detail, if not always accurately. In Arabic countries during the same period, mapmaking was more sophisticated. During the 12th century, the Arab scholar Muhammad al-Idrisi produced a comprehensive atlas entitled *The Amusement of Him Who Desires to Traverse the Earth*. With the development of improved astronomical instruments, and the setting up of observatories, Arab scholars like al-Idrisi were able to measure the arc of a meridian. This allowed them to suggest an accurate calculation for the Earth's circumference and map more precise distances. Muhammad al-Idrisi's map was one of the most accurate in the world at the time and its information was still in use centuries later.

FROM MAPS TO CARTOGRAPHY

As cultures began to travel farther for trade and colonial exploration, the need grew for more advanced and detailed maps. From around the middle of the 15th century—the beginning of a period known as the "Age of Discovery"—there began widespread exploration in Western Europe, and the subsequent mapping of the Americas, Africa, and Eurasia. Portuguese nautical charts developed the use of rhumb lines (the imagined lines, commonly used in maritime navigation, that cross the Earth's meridians all at the same angle). The Dutch, with their domination of seafaring and trade, created maps that were not only accurate but so ornamental that they were considered works of fine art. In 1569, the Flemish cartographer Gerardus Mercator invented a method for presenting a spherical globe as a flat map. Known as the Mercator projection, it is still used today.

Advancements in printing and surveying during the 18th century led to greater improvements in cartography. In surveying, the use of the vernier scale on calipers and quadrants meant greater precision measuring and led to more accurate mapping of distances and gradients.

With the further development of printing, handmade maps of varying quality were replaced with more accurate reproductions, which meant information could be more widely disseminated.

Moving on to the 19th and 20th centuries, the arrival of the airplane, space flight, and satellite technologies meant that aerial photography could be used to create even more accurate large-scale maps.

This brings us to the 21st century and the advent of the information and technology revolution. Maps today are generally produced with the use of advanced plotting software, spatial analysis, and image processors, all via computer screens. The digital navigation systems and maps of Google Earth may be accurate and convenient, but in comparison to the hand-drawn map, there is a certain coldness to them. In all its beautiful fallibility, hand-crafted cartography offers something digital maps could never do; it reveals something richly fascinating about a given landscape, its culture and history, and the unique character of the cartographers themselves.

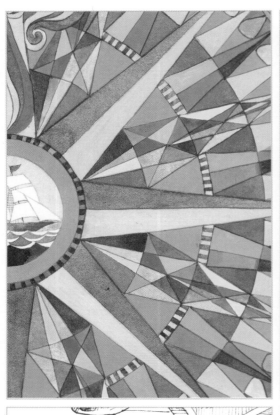

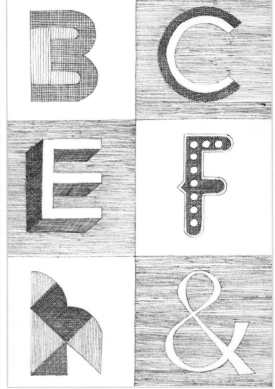

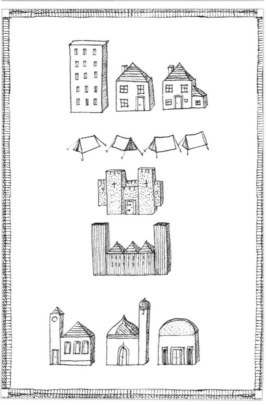
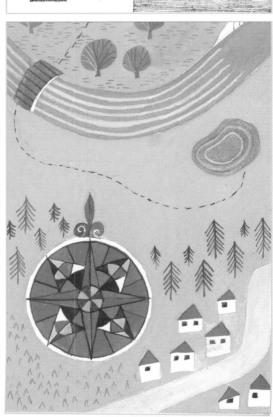

SECTION 1
MAP ANATOMY

COMPASSES

Compass roses are a familiar feature of maps, created to help the user orientate themselves or navigate from any point. They are used to show the four cardinal directions—north, south, east, and west—and sometimes the intermediate directions (northwest, southeast, etc.) as well. Generally, contemporary maps show true north (the position of the North Pole) at the top, although this hasn't always been the case in centuries past.

Compasses have been used to locate north using the Earth's magnetic field for almost 2,000 years. The Chinese of the Han dynasty (206 BC–AD 220) first used naturally magnetized iron ore, called lodestone, which freely aligns itself with the magnetic field. Later, compasses were made with iron needles that had been magnetized by striking them with a lodestone. Modern devices, such as smartphones, can be used as compasses because they contain a sophisticated magnetometer that relies on sensors encased in an electronic chip.

The earliest-known compass rose to appear on a map was drawn by Abraham Cresques, a cartographer from Majorca, Spain, in 1375. Since then, the rose has continued to be a highly decorative and useful design element of mapmaking .

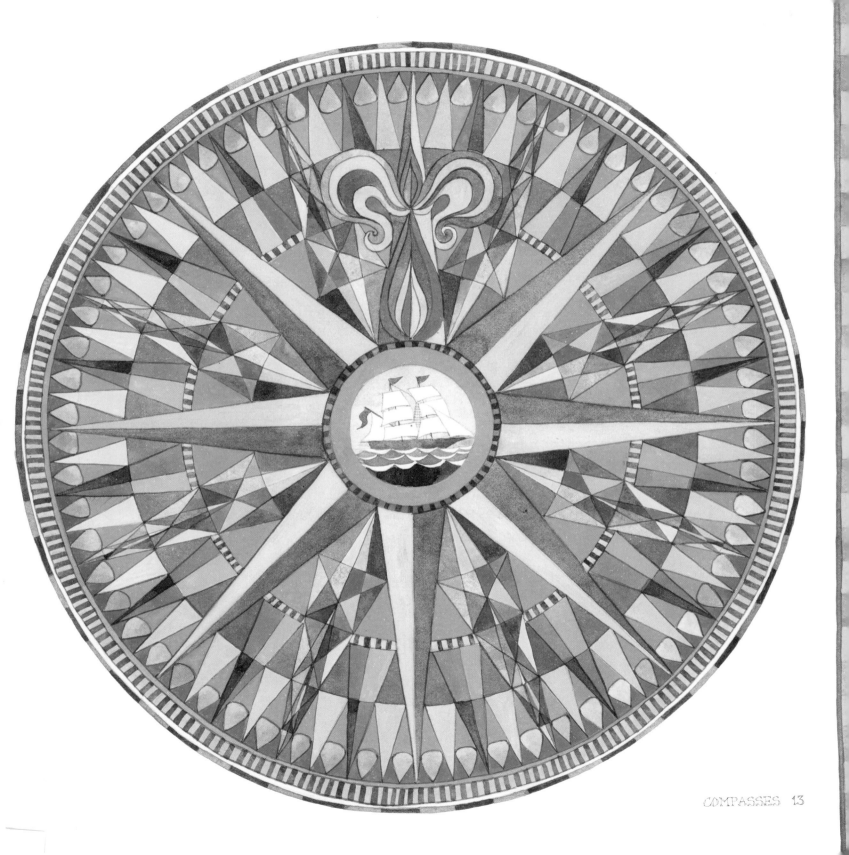

1

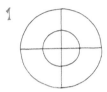

Start by drawing two concentric circles—a small inner circle and a larger outer one—then use a ruler to draw a vertical line through the marked center point of the circle. This is your north (at the top) and south (at the bottom). Draw a horizontal line (at 90 degrees to your vertical line) through the center point of the circle, crossing the first line. Use a protractor for accuracy. This is your west (on the left) and east (on the right).

2

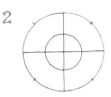

Starting from the top point of your circle and working clockwise, use a protractor to make marks around the circle at 45 degrees and 135 degrees. Then flip the protractor over and do the same thing for the other half of the circle.

3

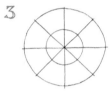

Using a ruler, join each mark to its opposite point, making sure your line goes straight through the center point each time. You now have your eight compass points: (clockwise from the top) north (N), northeast (NE), east (E), southeast (SE), south (S), southwest (SW), west (W), and northwest (NW).

4

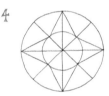

Using a ruler, draw a diagonal line from the outer circle at point N to the inner circle on the NE line. From here draw a diagonal line to the outer circle at point E. Continue this pattern all the way round your compass (outer E to inner SE, to outer S, to inner SW, etc.) until you reach point N again. You should now have created a four-pointed star shape, with arrows pointing to the cardinal directions of the compass.

5

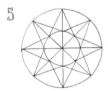

Now, starting at outer-point NE, draw a diagonal line to the inner circle on the E line. From there draw a diagonal line back out to the SE point on the outer circle. Continue: outer SE to inner S, to outer SW, to inner W, to outer NW, to inner N, returning to outer NE. You should now have created an eight-point star shape, the new points of the star indicating the intermediate directions. This is a full compass rose.

— OVER TO YOU —

Consider a color scheme for your compass rose that
complements the intended map. I gave the compass points
on my design a colorful geometric pattern in sea-blue
and green gouache and watercolor (see page 13).

For decoration, you could use contrasting colors on the cardinal and
intermediate points, as I used for the compasses in the travel journals
on pages 138–139, add geometric patterns, or maritime imagery.
My design on page 13 has an image at the center and a fleur-de-lis
pointing north that echo the design of many traditional compasses.

Use serif lettering for a traditional or historic feel, or sans serif
for something more contemporary. Usually the cardinal points are
abbreviated to N, S, E, and W, but they could also be written out
in full. Experiment by using contrasting lettering styles
for the cardinal and intermediate points.

To add more technical detail and complexity, you can also add the
points between the cardinals and intermediates at 22.5 degrees,
67.5 degrees, 112.5 degrees, and 157.5 degrees. For reference
see the compass rose on the Sensory Map on page 117.

Creating a perfect compass image requires precision, especially if it
is fairly small, so I suggest using materials that allow you to create
clean lines, such as a sharp pencil, a fine paintbrush, or nib. Inks and
watercolors also lend themselves to maximum control, and using
an artist's magnifying glass can be helpful for fine line work.

SERIF LETTERING AND CURSIVE SCRIPT

Hand-lettering is one of the joys of making your own maps. There are so many beautiful old maps with incredible calligraphy. A *serif* is a technical typography term, describing the wider projections at the ends of letters in typefaces and fonts such as Times New Roman. Using serif lettering suggests the old-time glamour of maps, when travel was an exotic dream and a single atlas cost the equivalent of a week's wages.

The traditional story goes that the serif comes from Roman carvers following the form of letters that had been painted on to stone—the brush marks, spread out at the tops and bottoms of letters, being replicated by the masons. Serif typefaces—which have serifs, as opposed to "sans serif" typefaces, which don't—were once considered to be easier to read in printed form, although thinking has now changed somewhat. Maps between the mid-15th century (after the invention of the printing press) and the 19th century all used serif letters, so the look has a more traditional, historic feel.

A NOTE ON CURSIVE SCRIPT

I often use lettering in my maps that looks like traditional script—the kind of writing my grandma used. Digital fonts like this are called "cursive script fonts." The letters are usually joined up and are sometimes given extra swirls and loops for added character. It's easy to do this by hand and just requires a little practice and experimentation.

Start by using a pencil to write out a word in lower-case, joined-up script. Try to draw the letters at an angle sloping to the right (angle your paper slightly to the left if it helps you to do this). If you prefer a very regular script, use a grid (see page 19) to keep your ascenders and descenders at the same level.

Although it may look simple enough, this kind of formal lettering can actually take many years to perfect. However, with the hand-drawn look, you can take more liberties and still achieve a highly desirable effect. The more practice you have, the more confident you will become, and using a grid may become unnecessary. You can use your hand-drawn lettering to give your maps unique style and character.

Look at any letters with ascenders. Instead of straight, vertical upward lines, try giving each stroke a slight curve so that you create a loop of upward and downward strokes. Do the same for letters with descenders, making them loop before they connect to the following letter at the baseline (remember that uppercase letters stand alone and don't connect with the lowercase letters).

Try giving letters with cross strokes (like f's and t's) a slight upward slant and a little curl at the ends. You could lengthen them horizontally so they extend to the end of the word. However, only use this last technique with one cross-stroke letter per word, otherwise it looks excessive.

You could add a flourish to the last letter of a word, for example, by continuing the last stroke to end on or below the baseline, adding an ornamental curlicue or swash. Think about thickening one side of each letter. Traditionally the upstrokes are thicker than the downstrokes.

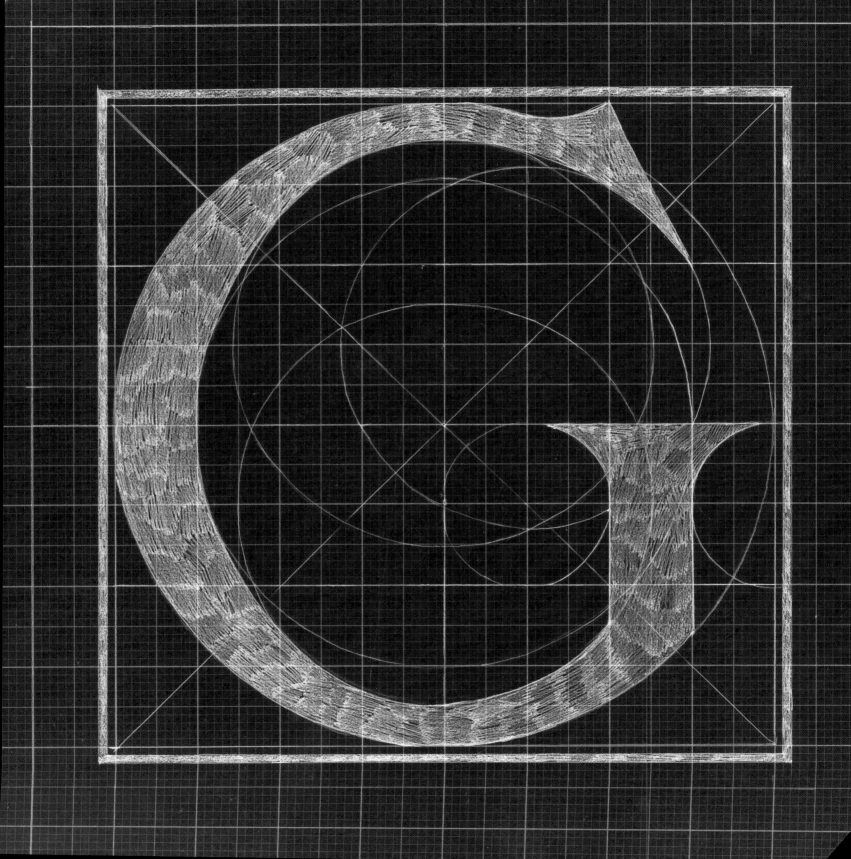

– OVER TO YOU –

First, create guidelines on which to set your letters. To do this, start by drawing a horizontal line across your page. This is your baseline, where your letters will sit.

Next, draw a parallel line a little above your baseline. This is your x-line, and the majority of your lowercase letters will hit this line.

Next, draw a parallel line above your x-line. This is your "ascender" line. Examples of letters with ascenders are *f*, *h*, *k*, *l*, and *b*. Traditionally the top of your capital letters should finish just short of this line.

Finally, draw a parallel line below the baseline. This will be your "descender" line. Descenders are the parts of the letter that fall below the baseline. The letters *q*, *y*, *p*, *g*, and *j* all have descenders.

Starting from the baseline, write the alphabet on this grid you have made, using lower- and uppercase letters. Where the strokes finish at a line— any line—flare out the ends as a serif. Although the lowercase *t* has a shortened ascender, give this a serif, too.

Some letters will have strokes that finish more horizontally, such as the capitals *T*, *L*, *C*, and *S*. Give these letters vertical or angled serifs at the ends of the strokes.

Formal typefaces often have thickened downstrokes (on the left-hand side) and narrower upstrokes (on the right). Researching serif fonts online can be useful for further inspiration and guidance. Practice drawing the same letter again and again, testing out different looks with thick and thin strokes and decorative accents, till you find a style you like.

SANS SERIF LETTERING

The other major category of lettering is called "sans serif." Literally meaning "without serif," this group has letters without small projections at the end of strokes. Although they have been around since the early 19th century, they truly came into their own in the 1920s and 1930s, with iconic typefaces such as Gill Sans and Futura. Despite the early origins of these typefaces, they are generally considered to create a more contemporary look.

Most modern printed and online maps use sans serif lettering, partly because it's easier on the eye when presenting a sea of complex cartographical information. If you're using a mixture of different lettering styles, a sans serif can be used to establish a hierarchy of information and make important labels stand out more clearly. A lovely example of this is a 1961 road map of Jamaica, published by the fuel company Esso, which uses serif lettering and decorative lettering to label counties and seas, with sans serif lettering for towns and cities. For a driver or passenger reading the map while in motion, this makes it really easy to spot the main towns.

Although sans serif lettering might look plain and uniform, there are in fact various different categories—geometric, humanist, grotesque, and so on—each with its own distinctive letterforms. When deciding on lettering for your own map, a little research might help you find a font to complement your own theme or style.

This letter *f* has a curved outline with rounded corners, which makes it look fatter, and also more informal and fun. I've also added cross-hatching and circles to fill in the letter shape and make it more decorative. Other decorative patterns you could use are stippling (shading using small dots or marks), checks, and flowers.

A 3-D effect makes lettering really stand out and is interesting when used in map titles. Here I've thickened the left side and bottom of the letter, but you can add dimension to whatever side(s) you want as long as they're adjacent and applied consistently. The letter itself has been left white to make it stand out from the dimensional elements, which are shaded.

This letter *D* has been created using adjoining squares to create a pixelated look. This could be good to use for a futuristic-style map, or in a platform-game map (see pages 60–63). Simple line shading helps differentiate each square, but this could also be achieved by using different colors for each square.

Some letters, such as *B*, *D*, and *O*, include an enclosed opening, known in typographical terms as an "aperture." I customized the apertures of the letter *B* so that they blend in with the vertical line (or "spine"). This is a great example of how you can experiment with typographic features and create your own customized lettering.

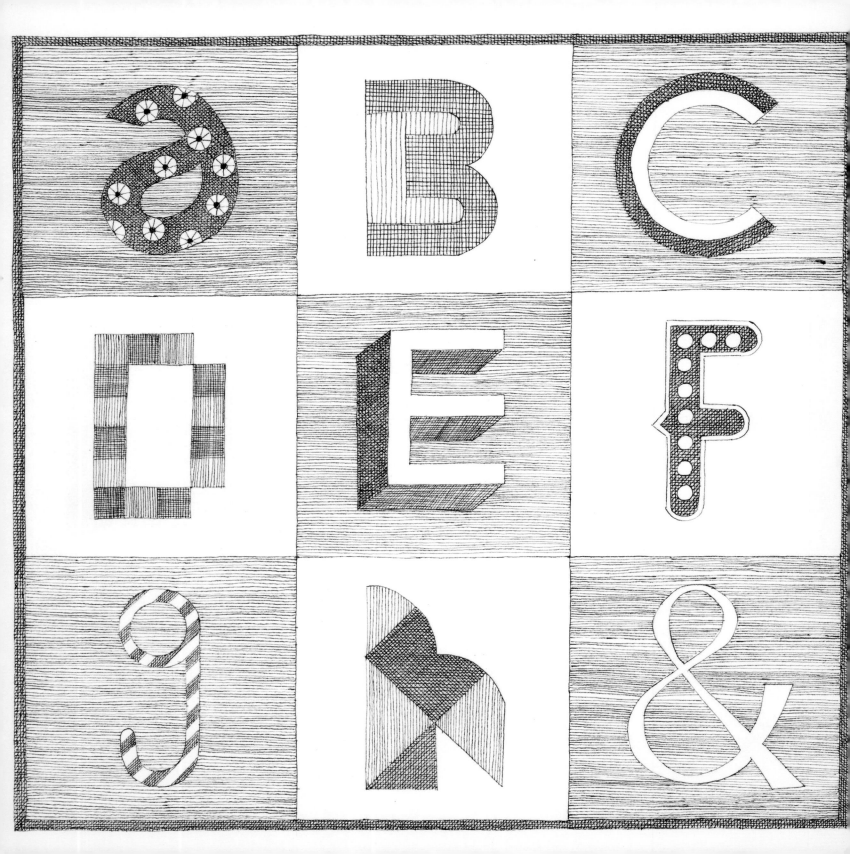

– OVER TO YOU –

1

Using a pencil, write out the alphabet. Remember there is no need to add serifs. Use these simple letters as skeleton bases to create different styles of sans serif lettering.

2

Consider whether you want your lettering to look formal or more relaxed. For a neat, uniform look, create guidelines (see page 19) or use the graph paper in the templates section. For something looser and more relaxed, work freehand.

3

Experiment with the width and height of your letters. For example, write the letters stretched out vertically so they look long and thin, or stretch them horizontally so they become wide and squat. As well as the form of the letter itself, you can also experiment with the spacing between letters.

4

Consider different decorative treatments for your letters. Try filling them in with colors or patterns, adding drop shadows to create a 3-D effect, or customizing particular typographic features. Ideally these treatments will incorporate elements from your map so that the lettering and illustration work in harmony.

5

Use the examples on the opposite page as inspiration for developing your own unique sans serif font. Alternatively, research sans serif typefaces and find something that matches the theme of your map. For example, some typefaces evoke a particular time period or form of technology.

CARTOUCHES

Cartouches are the often decorative panels that you see on many traditional maps, informing the viewer of the map's location, the name of its creator, and the date it was drawn. Sometimes they also include an indication of scale. These are all important elements in formal cartography.

Historically, maps were often commissioned by states, expressing their ownership of a country and enforcing any boundaries. For the viewer, the cartouche is important, as it indicates who has ordered the map and therefore whether there is a political agenda in the representation. What is featured and what is left out is always at the discretion of the mapmaker, so it is important to know who they are.

A cartouche's date is also important, as a landscape changes with time. A map is only a snapshot of a place at a certain point in history. Boundaries and political allegiances are always in flux—as are the preoccupations of the cartographer. You need to know whether the map you are using is up to date.

Cartouches first seem to have appeared on maps in the 16th century in Italy. Cartouche styles, be they elaborate or simple, have varied over the centuries, but their heyday was certainly during the baroque period, when more decorative ways to title maps were created.

MAPPING A MESSAGE

A lovely example of a cartouche appears on French cartographer Guillaume de L'Isle's *Map of Canada or the New France and the Discoveries That Have Been Made There,* from 1703. It is highly decorative, complete with scrolls, vases, and filigree touches, as if carved from a piece of marble. It features illustrations of native animals and plants. It also depicts the domination of the French over Canada's native people, something we would today consider problematic, but which makes this map an interesting example of how cartography has historically collided with political agendas and propaganda.

KEEPING THINGS CLEAR

More contemporary cartouches can be found on old road maps, from the times when cars first became more available to the general public. The Kendall Refining Company produced an official road map of New York in 1933, with a cartouche that is simple but clearly based on the old scrolls of historical maps. Decoration is kept to a minimum but there is still a nod to symbolic illustration, with a small car vignetted at the bottom. The lettering is clean and sans serif, and all the information (location, commissioner, and date) is very clear—demonstrating that directness can sometimes be as visually effective as decoration.

MAKE IT PERSONAL

Less formal maps—for example, those that I make—don't always need to have a cartouche, but including one will always provide a useful shorthand for any viewer looking at the map. My own cartouche is for an imaginary map of Brooklyn in New York (see overleaf). In the style of a baroque cartouche, it's elaborately decorative, but I've also included contemporary symbols that represent the district, to bring it up to date and give my own personal take.

A cartouche might feature plants from the mapped area.

Sometimes familiar symbols may be used as vignettes.

In my cartouche (overleaf) I used a crown to represent Queens, NYC.

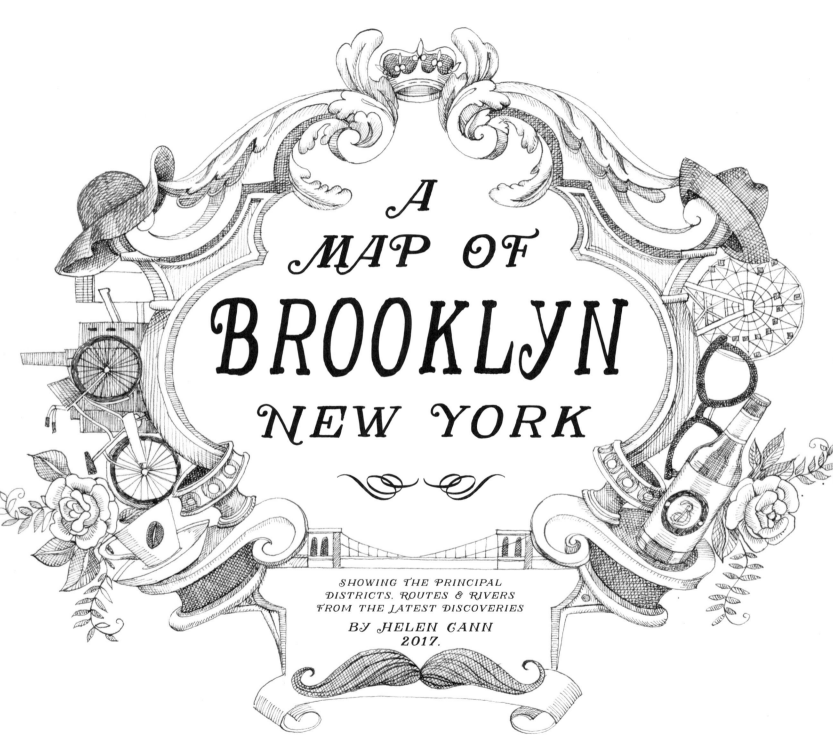

~ OVER TO YOU ~

1

To help you get started, find the cartouche
templates at the back of this book.

2

Start by choosing your subject matter. It could be your
hometown or somewhere entirely different, but you
should make sure that you know the place well.

3

Identify the most important physical features of
the location, such as a building or statue that's iconic
to the area, and add them to your map.

4

Are there any plants or animals that are very common in
your chosen place? Create small drawings of these to use
as symbols around the shield shape of your cartouche.

5

If there are any people in your cartouche, include features
that are distinctive to the people you would find in the
place, such as particular clothes, hairstyles, or accessories.

6

Your symbols should form part of the shield itself
and not simply float in the air around it.

7

Try to mirror the scale of symbols on opposite sides
to keep the balance even in your design.

8

For a more baroque-style cartouche, you could start at the
top of the shield with a central symbol and work outward,
adding your symbols to either side.

9

If your cartouche is to have a particular theme or an
underlying message (like the French map of Canada),
make sure your choice of symbols reflects this. A map of
great patisseries for example, is crying out for a cartouche
decorated in decadent-looking pastries.

10

Use hand-lettering to add the title, date, and
the name of the mapmaker. Use a serif font to give
a historical feel, or a sans serif for a more
contemporary look (see pages 16–23).

KEYS AND SYMBOLS

Traditional maps rely on symbols as shorthand, to describe every feature you can see in a 3-D landscape on a 2-D plane. The symbols of hand-drawn maps are often represented as if being viewed from the side, although the landscape is shown from a bird's-eye view.

Symbols have been used in maps since the beginning of human history. An ancient Babylonian map of Gasur (later known as Nuzi), created on a clay tablet, is one of the oldest maps in the world. The surface of the tablet is covered with symbols representing the natural features of the landscape. Scratched and impressed into the clay is a map with flowing watery lines indicating a river meandering between two ranges of mountains, which are symbolized by multiple mounded forms—crude but effective. The symbols might not be sophisticated by modern standards, but it's still possible to locate yourself with this map today.

A more detailed key of symbols is used by the Ordnance Survey (OS), the national mapping agency of Great Britain. Their maps have been produced since 1745, when they were made to document the geography of the Scottish Highlands more effectively during the Jacobite Rebellion. By the early 19th century, whole teams of men were mapping the entire country, systematically measuring distances and noting place names (if not always correctly!). I love the old stories of teams traditionally holding a "plum pudding" party at the end of each survey.

In modern OS maps, the symbols are very comprehensive, and each icon is distinct but simple. They include electricity pylons, wind turbines, and heliports. In my own example on pages 30–31, I kept things simple by focusing on the main elements of each feature. The most basic of details, such as a couple of windows, a door, and familiar triangular roof, indicate "house." Different tree types are based on simple geometric shapes like circles and triangles.

– OVER TO YOU –

1

Select an area of land you wish to map out and write a list of the significant features. Depending on the place you have chosen, your list might include categories such as natural features (e.g., mountains, lakes, rivers, cliffs, beaches, forests), man-made landmarks (e.g., buildings, roads, highways, footpaths, harbors, or airports), or historical sites (e.g., battlefields, ruins).

2

For each item on your list, draw a simple symbol that best represents that category of thing or place. You can be as specific as you like with your categories and symbols. For example, forests can be deciduous, coniferous, or mixed. Buildings can be separated into houses, stores, factories, or places of worship. Go outside and make some sketches, or consult an existing map, if you need references.

3

Each symbol should be easily identifiable (such as a boat to symbolize a harbor) and distinguishable from other symbols on your map, but avoid adding too much detail that will make the symbols difficult to use repeatedly and on a small scale.

4

Where a feature covers a large space on the map— for example, a field or a forest—it's a good idea to use a particular pattern in your symbol that can be easily repeated. Color can often be used to differentiate spaces, but if you have to use only one color, try applying different types of mark to make each feature distinct. Check out Hungarian-born cartographer Erwin Raisz's maps for some ideas. His hand-drawn landform symbols are beautiful.

5

These symbols will now become your key, and traditionally this list will be included on your map, either in a bottom corner, or if you are using one, connected to a cartouche. Wherever a feature appears on the landscape, represent it with the appropriate symbol on your map.

MAP OF
WHITE CLIFFS & ST. BARNABAS
KEY TO SYMBOLS

 Houses & Apartments

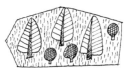 Managed Forest

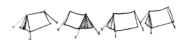 Campsites

 Nondeciduous Forest

 Castles & Stately Homes

 Deciduous Forest

 Factories

 Orchards

 Places of Worship

 Fields

 Windmills & Turbines

 Scrub

 Lighthouses & Lightships

 Downland

 Marshland

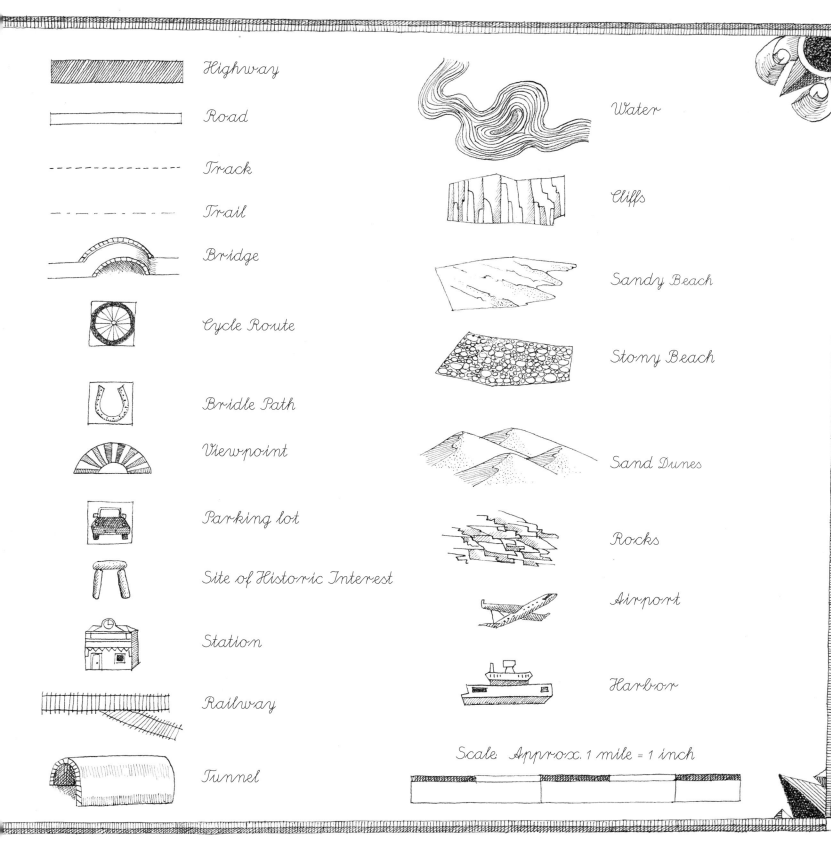

Highway

Road

Track

Trail

Bridge

Cycle Route

Bridle Path

Viewpoint

Parking lot

Site of Historic Interest

Station

Railway

Tunnel

Water

Cliffs

Sandy Beach

Stony Beach

Sand Dunes

Rocks

Airport

Harbor

Scale Approx. 1 mile = 1 inch

BRINGING THE BASIC ELEMENTS TOGETHER

Standard maps, and most certainly historical maps, present 2-D versions of 3-D landscapes in a recognizable format so that they can be understood by all. The appearance of the compass rose, the cartouche, the key, and the neatlines (borders) instantly tells the viewer that he or she is looking at a map. Bringing these core elements together in a cohesive style is a crucial part of any successful mapmaking journey. The following maps show you examples of how you might do this in your own maps.

The *Carta Marina*, a highly detailed 16th-century map of the Nordic countries by the Swedish theologist Olaus Magnus, is a true "Here be dragons" kind of map, made before the time of sophisticated cartography, when mapmaking relied on reports by word of mouth and on-the-ground documentation. Magnus depicts his seas swimming with monsters, mermaids, and whales. Iceland features exploding volcanoes, and above the Arctic Circle there are angry locals in snow homes. Warmly wrapped Estonians appear to be skating across the Gulf of Finland. When creating your own rich, decorative map, you could take inspiration from this map, bringing together a busy multitude of compass roses and annotated neatlines, with a thorough covering of various symbols.

A SIMPLE APPROACH

J. R. R. Tolkien's *Map of the Wilderland* in *The Hobbit* is an example of how you can bring the core elements of mapmaking together with greater simplicity, based on a more modern but fantastical style. The compass rose points north, of course, but it's reduced to a simple cross of cardinal points. The neatlines are double-ruled and basic and the cartouche is square but nonetheless decorative. Tolkien shows us that rules can be broken by not including a key. Instead, all the landscape features are illustrated and named in his unmistakable lettering reflecting the Middle-earth setting.

I, like Tolkien, valued simplicity in my own map (see overleaf) but added a subtle use of colors to describe geography. For example, look at the key to see how I differentiated a meadow from a marsh—this is something you may wish to use in your own map. In keeping with the simple design, I avoided superfluous decoration in my cartouche, and just attached the key to it.

My use of symbols distinguishes a mixed forest (seen here) from a pine one.

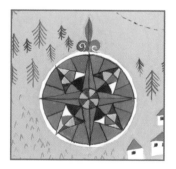

I avoided annotating the cardinal points on my compass rose.

I made subtle use of patterns to distinguish between different topographical areas.

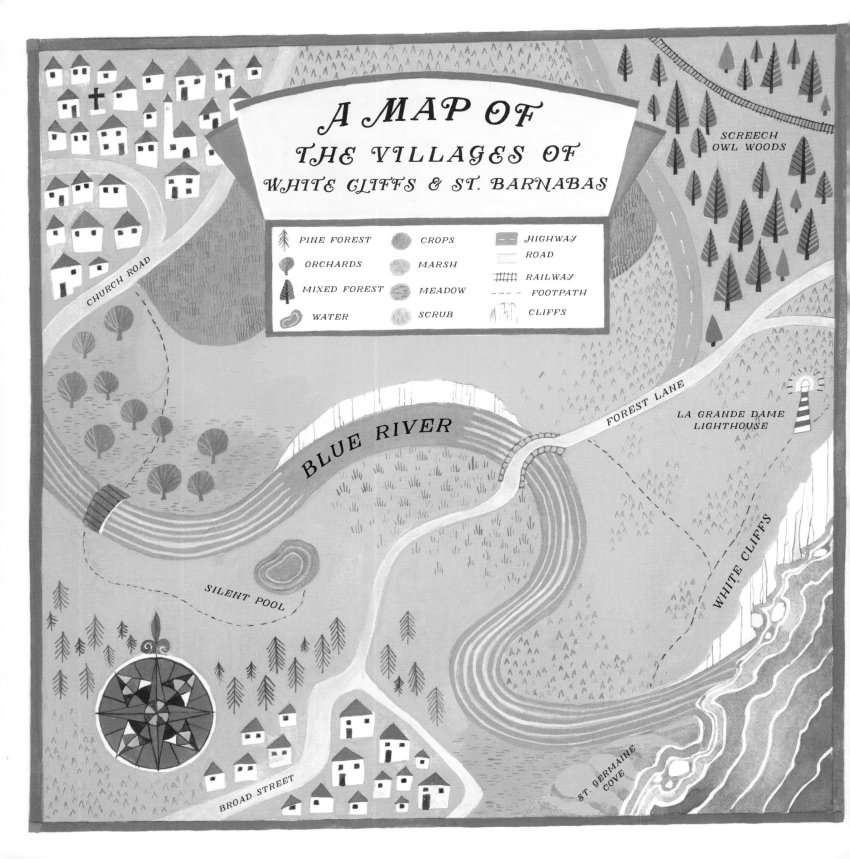

– OVER TO YOU –

Once you have decided on your location, start drawing your map by defining your neatlines—the border delineating and defining the extent of geographic data on your map.

Decide what style you will use for your map. For a map like Tolkien's, keep the decoration simple; for a more complex map, such as the *Carta Marina*, you could consider including annotations.

Make your compass rose, cartouche, and key in a cohesive style. In my map, I elaborated each of these elements with patterns or images reflecting the colors or theme of the map itself. Alternatively you could make them more distinguishable from the map itself by using a contrasting color scheme or style.

Choose where to place your cartouche. I placed mine in the center to catch the reader's eye immediately, but Tolkien placed his in a far corner, perhaps to focus more on the Misty Mountains and Forest of Mirkwood.

Make sure your lettering reflects the overall style of your map. Sans serif type looks contemporary and is easily read; serif fonts give a more historical appearance. Using your own distinctive hand-drawn lettering will help make your map look truly unique.

TILLY

Tilly is an illustrator based by the sea in Brighton, UK.

Drawing inspiration from the everyday and the odd, Tilly enjoys creating characters in her work, based on those around her. She has made maps for various magazines, books, and even an opera house. For the last three and a half years she has created maps for a monthly feature in the *National Geographic Traveller*. You can see more of her work online via her website: www.runningforcrayons.co.uk.

Q: How did you get into illustrating maps?

I first started illustrating maps when I was commissioned by the *Observer* newspaper to create a map of the east end of London. From that point I started creating my own maps of other areas of London as well as other towns.

Q: Can you tell us about your map of La Paz, shown here?

This map is of La Paz in Bolivia, which was a commission for a feature in the *National Geographic Traveller*. I always research a place beforehand so I can get a feel for it, and I found researching this map particularly fascinating. What caught my eye was the women's beautiful traditional dress, including bright shawls, long embroidered skirts, and braided hair poking out of their round hats. I also wanted to emphasize the amazing colors, so I used a strong, bright palette for this map.

Q: What tips would you give to people interested in creating their own hand-drawn maps?

Personally I prefer to focus on portraying the feel of the place I am illustrating, rather than creating a map as a means of getting from A to B—though obviously it has to be geographically accurate. Pick out a few key elements of the area to use in your map. For example, if it is a rural area, look at the local wildlife, or if it's a town, you could research popular types of fashion or cultural dress. It is also good to use color as a way of expressing the atmosphere of a place.

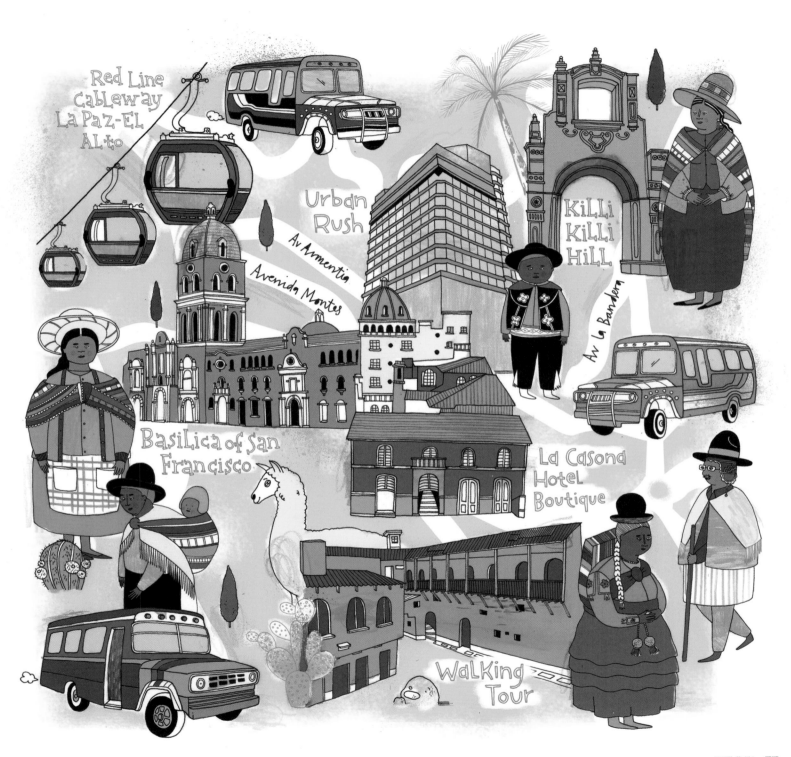

Red Line
Cableway
La Paz-El
Alto

Urban
Rush

Killi
Killi
Hill

Av Armentia

Avenida Montes

Av La Bandera

Basilica of San
Francisco

La Casona
Hotel
Boutique

Walking
Tour

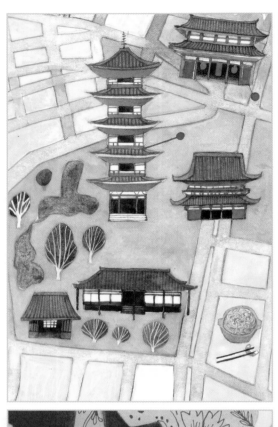
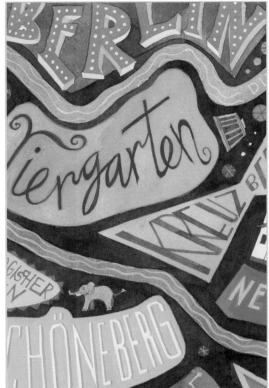
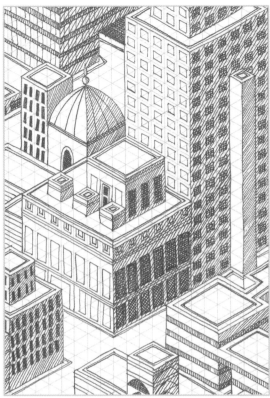
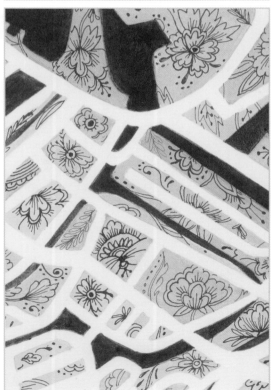
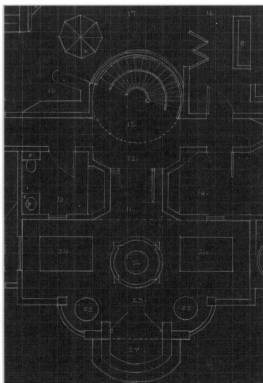
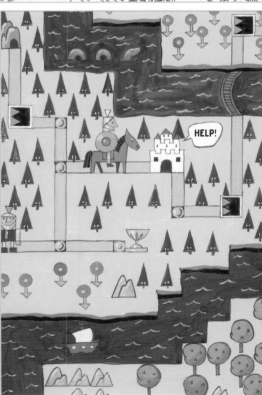

SECTION 2
TYPES OF MAP

MAKING MAPS WITH PICTURES

Maps can be fully functional without any text at all. A well-chosen and carefully designed symbol can effectively pinpoint the main features of a landscape, and communicate the necessary information. Not only is it possible for a text-free map to be clearer, there is also scope for a host of aesthetic possibilities.

A RICH HISTORY

The first maps on paper were almost all pictures and had few words. The *Geografia di Tolomeo* is a 15th-century Italian translation of the atlas and writings of 2nd-century Greek cartographer Ptolemy. These maps were highly influential on the Renaissance mapmaking of the time. They show cities such as Jerusalem, replete with perfectly drawn churches, aqueducts, and sepulchers, in pale pinks, faded blues, and golds. They feature only a small amount of text, but everything is marked clearly using symbols, and the maps are easy to follow.

THINKING IN PICTURES

Sarah Burwash, a contemporary illustrator, makes hand-drawn maps that use mainly pictures. Using pale watercolors and inks on a white background, she maps places she knows. My favorite example of her work is her 2011 map of Red Clay Farm for the White Rabbit Arts Festival in Nova Scotia, which shows all the features of a festival. She uses color to pick out the trails and rivers—they are given extra importance because hiking and swimming are an important part of the festival. Vegetation is quietly decorative, drawn with sensitive black marks. Sarah varies her lines using dots, dashes and upturned V's, making patterns to distinguish different kinds of vegetation rather than using color. Trees and tents are all individually drawn, giving unique character and personality to the map. It's designed necessarily from a bird's-eye view for audience usability, but it feels as though it's been mapped from the ground using features both seen and sketched by the artist herself.

PICTURING YOUR EXPERIENCE

My own map overleaf is of Asakusa, Tokyo—a neighborhood filled with temples, where an exotic, five-story pagoda competes with the oldest amusement park in Japan. A week in Tokyo is barely enough time to explore this city of neon lights, birdsong-filled parks, and soft-red and gold temples. It certainly is a place to get lost in, and I did, many times! My lack of Japanese made it hard to decipher road names, and a bad sense of direction meant I walked a mile before I realized I was going the wrong way. In situations like this, picture maps come into their own.

In my map, I have added the features that were most important and memorable to me: the place where I stopped for some sweetly scented Japanese tea; the confectionery store where I bought delicate mouthfuls of red bean treats packaged in beautiful black boxes; and the public *onsen* that I visted to enjoy a traditional bath. At the end of each day, I would always visit the same restaurant for a bowl of ramen noodles.

For my map I picked symbols that would be easily recognized and understood (i.e., the tea, candies, and noodles) and that I felt summed up the heart of each location. For the buildings, I used sketches and photographs as references, choosing the most important parts of each icon to keep them simple but recognizable. I made the gridded roads and the in-filled spaces between them a knocked-back green and blue to help make the pictures more prominent and contrast effectively with the rich, predominant red of the temples.

- OVER TO YOU -

Decide on the place you want to map, then make a list of the main visual features you would like to depict. These could be places that evoke strong memories for you, or that are important to the area, such as the trails and rivers at White Rabbit Arts Festival.

As an alternative suggestion, you could theme your map and concentrate on a single topic, for example, places to eat or great bars in your neighborhood.

Create symbols for each feature. It might help to practice making small sketches first as reference. Use photos to jog your memory, if it helps. Buildings could be depicted by a realistic representation or, alternatively, by a symbol—a cup of coffee to symbolize your favorite café, for example.

Plan your map in pencil. Draw out the main roads or areas (such as vegetation or forests). If you want your map to be accurate, refer to an existing map to check the detail and scale. Otherwise you can work from memory.

Now add the symbols you created in the desired places around your map. Experiment with scale to make your symbols stand out. If your symbol is quite detailed and would benefit from being large, or if you want to accurately depict the locations of your landmarks, you could use leading lines that join your symbol to its precise place on the map. Have a look at my map to see how this can work.

Ink in and give some detail to the background. If you are working mainly in black and white, think about using a variety of mark-making—dots or dashes or scribbles—to indicate different areas. If you are using color, keep the background to a muted color palette so it doesn't interfere with your symbols.

There are various ways you could use color and pattern to make your picture symbols stand out and give them due importance. Either make them all colorful, so they contrast with your knocked-back background, or give the most important features a bold color, like the gilded churches in Renaissance maps.

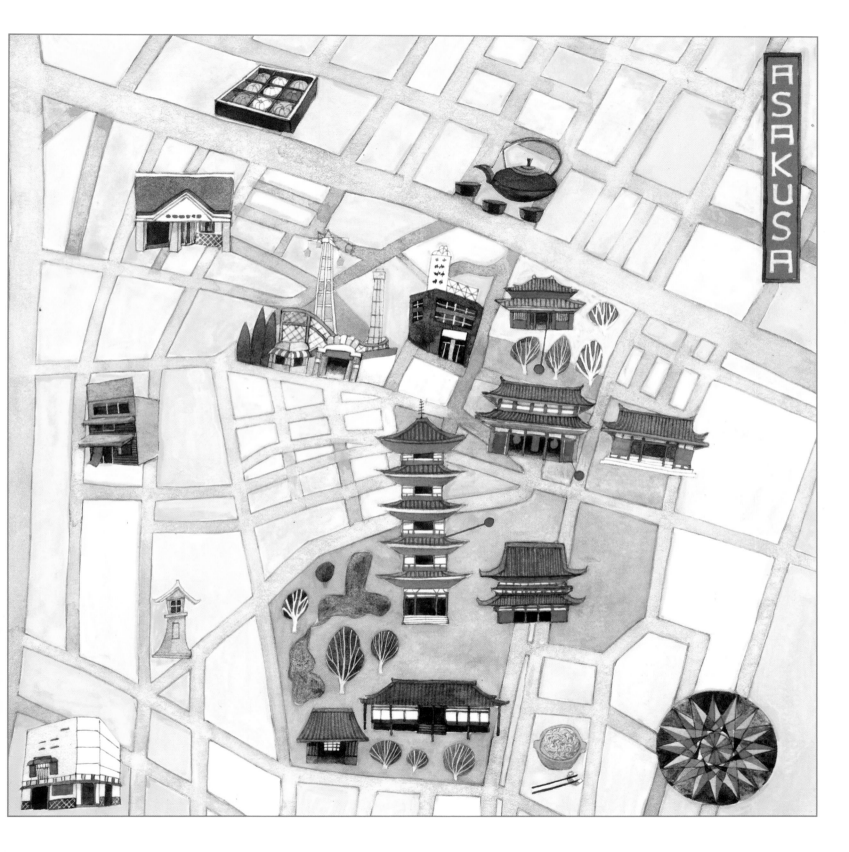

TEXT MAPS

Traditional maps usually describe the features of a place using both words and symbols. But maps can also say something about a place using no pictures at all. Designers, forever obsessed with layouts and fonts, have used type to explore the map format in a variety of different ways. Sometimes they simply describe the features of a place with text, dispensing with the visual complexities that lines and symbols bring.

Cartography designers Axis Maps' map of Boston uses text to fill all the available space. The size and boldness of type corresponds to the size and importance of each street. District names hover subtly in the background in contrasting colors. River names wave in an appropriate blue. It is the names, repeated over and over, instead of line markings, that effectively fill and delineate the space. Standard boundary demarcations are not used, and yet, despite the mass of type, each element functions well and is still easy to read.

MAKE IT INFORMATIVE

Contemporary historian Bryan Lloyd's 2011 text map, *The Wickedest Place in the USA 1895–1923* (apparently this was Chicago), has been designed less as an exercise in cartography or graphic design and more as a fascinating historical document. The usual grid of streets is marked clearly but the names of every bar and brothel that existed between the 1890s and the early 20th century have been meticulously hand-inked to fill each block. The text not only provides geographical information but also adds a flavor of old gangland Chicago with its mentions of flop houses, hop houses, tattoo parlors, and characters such as Big Maud and Al Capone—showing that carefully chosen features can make a text-only map a fascinating piece.

MAKE IT INFORMATIVE

My own map (see overleaf) has been inspired by the work of award-winning illustrator and hand-letterer Linzie Hunter, whose clients range from Nike to the *Wall Street Journal*. Her playful map of London divides the city into neighborhoods, which are positioned in roughly the correct geographical locations. Each name is written out in flat, clean colors, using a variety of typefaces and with each area housed in its own decorative frame.

Occasional iconic symbols of the city are dotted throughout the text: Big Ben, a red double-decker bus, or a black cab driving through the traffic jam of words. (No one said you had to be puritanical about not using symbols.) It favors a lively mood over geographical precision, and effectively gets across a feeling of enthusiasm for the places on the map—something I have also aimed to do in my own work.

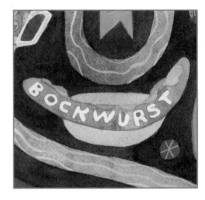

In my map of Berlin, the name of each area in the city is written in its own unique, distinguishable hand-drawn font.

Among my hand-drawn location labels, I included some recognizable symbols (such as bikes and cars). I also drew in the two main rivers running through the city center for an added sense of the geography of the city.

I incorporated text into some of my symbols, to emphasize the most iconic aspects of the city, such as Checkpoint Charlie and the famous Berlin bockwurst.

MOABIT WEDDING PRENZLAUER BERG

BERLIN

MITTE

FRIEDRICHS -HAIN

VIELSPASS

BIER

DIE SPREE

BOCKWURST

Tiergarten

KREUZBERG

CHECKPOINT

ALT- TREPTW

Charlottn burg

ZOOLOGISCHER GARTEN

NEUKÖLLN

WILMERS -DORF

SCHÖNEBERG

STEGLITZ

TEMPELHOF

SPREEWALD

– OVER TO YOU –

1

Before starting on your design, do some research on the geographical names and area divisions of your chosen location to get a sense of the character of each place. Use this research to inspire your hand-drawn typefaces.

2

You may wish to refer back to pages 16–23 of this book for some useful tips and tricks for creating your own hand-drawn lettering. Does your chosen lettering reflect the character of the area? For example, you might want a more formal serif font for a gentrified area or a bright sans serif for somewhere with a good nightlife.

3

Using light pencil marks, sketch out the basic geographical area, making sure all the districts and streets are correctly placed in relation to one another. Consider, as I did, adding simple geographical features like rivers to add to the sense of the area's geography without detracting from your text.

4

Decide on the theme and appearance of your map. Is your intention to focus on the historical documentation or geographical features of your location? Is there a message you would like to convey, and if so, how will you do this effectively using predominantly text?

AXONOMETRIC MAPS

An axonometric map is an easy way to draw a map in 3-D. It doesn't use true perspective, where there is a horizon line and things in the distance look smaller than in the foreground (foreshortening). Axonometry is sometimes called "parallel perspective" because most angles are the same—the lines are parallel to each other.

Axonometric maps are useful when you want to show a broad sweep of a landscape from above. Hatsusaburo Yoshida was mapmaking in Japan roughly a century ago. His brightly colored towns and temples are placed in jade-green mountains and fields that he had walked through for months before he started his first map. His maps are an example of axonometry because the buildings he depicts are drawn with angles parallel to each other. There is no use of a vanishing point on the horizon. The maps are shown in 3-D form from a bird's-eye view alongside roads and other local features, all marked with neat vertical labels.

German cartographer Hermann Bollmann is probably most famous for his maps of Manhattan in the 1960s. He was most interested in the buildings and, unlike Yoshida, he gave little attention to the surrounding countryside. His painstakingly detailed maps of cream streets and elegant gold and indigo skyscrapers are dashed with thousands of windows.

HOW TO DRAW AN AXONOMETRIC CUBE

Here's how to draw an axonometric cube that will
form the basis of your axonometric map.

1

Using the isometric paper in the templates
section of this book, draw a diagonal line
along the base of three triangles. Then draw
along the guidelines of the isometric grid to
create a slanting diamond shape.

2

Add some walls to your cube by drawing
vertical lines at each corner of your slanted
diamond. They can be the same height or
differ, depending on whether you want a
slanted roof or a straight one.

3

Now add your ceiling by connecting the top
ends of your vertical lines, as seen here. You
have just made an axonometric cube.

4

To make your cube look like a solid building
with only three planes—a left and a right
side and a roof—use an eraser to rub out the
lines you wouldn't be able to see in real life.

5

Add shade to one plane of your cube. Here the light is falling from
the right, carrying a shadow on the left; if the light were coming from
the left side, the planes on the right would be dark, or vice versa.

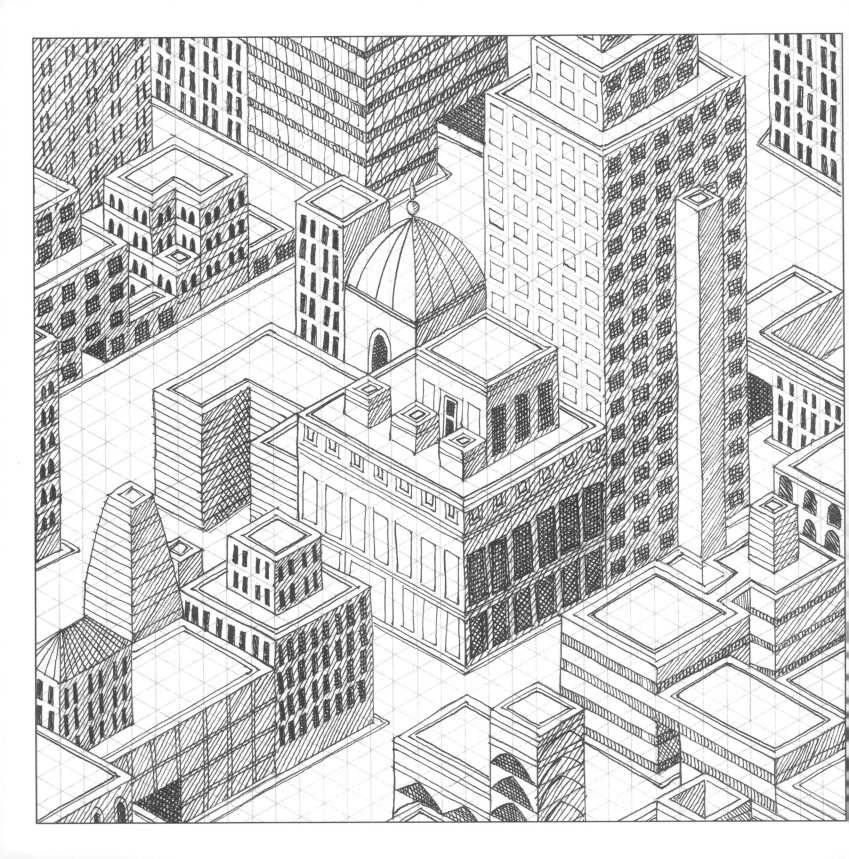

─ OVER TO YOU ─

Using the isometric paper provided in the templates section of this book, start sketching your map in pencil, drawing a series of 3-D-buildings based on the axonometric cube described on page 49.

The isometric graph paper will help guide your lines and keep the angles of your buildings consistent. Always start at the bottom of the page and work upward, which will help you build up the layers of your city streets.

When adding the walls, vary the heights of your building shapes to give the true sense of a city filled with skyscrapers. Don't put too many tall buildings at the front of your map, though, because this will obscure the buildings in the background.

When adding shade to the planes of your cubes, remember to keep your light source consistent across your map.

Customize your cubes with roofs, windows, chimneys, and doors, varying the shapes and sizes to create a dynamic cityscape.

Using axonometric projection makes detailing architectural minutiae much easier because there is no vanishing point. You don't need to worry about perspective, and the scale remains the same in the foreground as in the background. Have a look at my map to see how this works.

NEGATIVE-SPACE MAPS

When you read a map, your eye travels across its landscape, taking in each feature and piece of text. But what about the "empty" areas in between the roads and features? These are referred to as "negative space." The negative space in a map is just as important for understanding the layout of a place; it can even give us a sense of historical urban development.

Cartographers can map the negative space by keeping the positive spaces (the main features) a neutral color like black or white. In 2012, students at Columbia University Graduate School of Architecture, in collaboration with Audi of America, used just this technique to create an ambitious installation, entitled "Experiments in Motion," that mapped the relationship between motion, mobility, and design in the urban environment. Their 50-foot- (15-meter) long, aluminum structure showing a 1:1500 scale replica of Manhattan's road infrastructure was hung from the ceiling of a dark warehouse in New York. Just below this was suspended a layer of Plexiglas showing all the subways on the island. Light was projected from above, so all the streets and transit systems formed a shadow on the floor, and the negative space appeared as softly glowing squares. Although strictly speaking this is not an example of a hand-drawn map, the same principle can be employed with the use of black and white inks—or, like a number of contemporary artists, you can create map art simply by cutting away the negative space from a piece of paper.

CUTTING IT OUT

French artist Armelle Caron uses a cut-paper technique for mapmaking to great effect by examining the negative space in a number of cities around the world. Each city is presented with its road system in white and the negative space in block color. The negative space fragments are then copied and organized as a series of abstract shapes in neat rows next to the original. Although the fragments are displaced, it is still possible to tell which city they belong to. The spaces in her map of Istanbul, for example, are many and narrow, reflecting the ancient courtyards of the Grand Bazaar. They are distinctly different from the spaces in her map of The Hague, which are broader with a more standard geometry, reflecting a city that was planned mostly after the Second World War.

INCORPORATING PATTERNS

A long weekend in the Dutch city of Amsterdam found me cozied up in a bar, away from the mists rolling in from the North Sea. Poring over a tourist map, I became fascinated by the intricate concentric design of canals and streets that form, in spiderweb fashion, around the old town. Built in Amsterdam's heyday in the 17th century, this network is a beautiful graphic design of form and function and lends itself well to a negative-space map. After I had drawn the main street and canal system, I filled the in-between areas with patterns based on the traditional blue-and-white Delft pottery, which you can find everywhere in the souvenir stores.

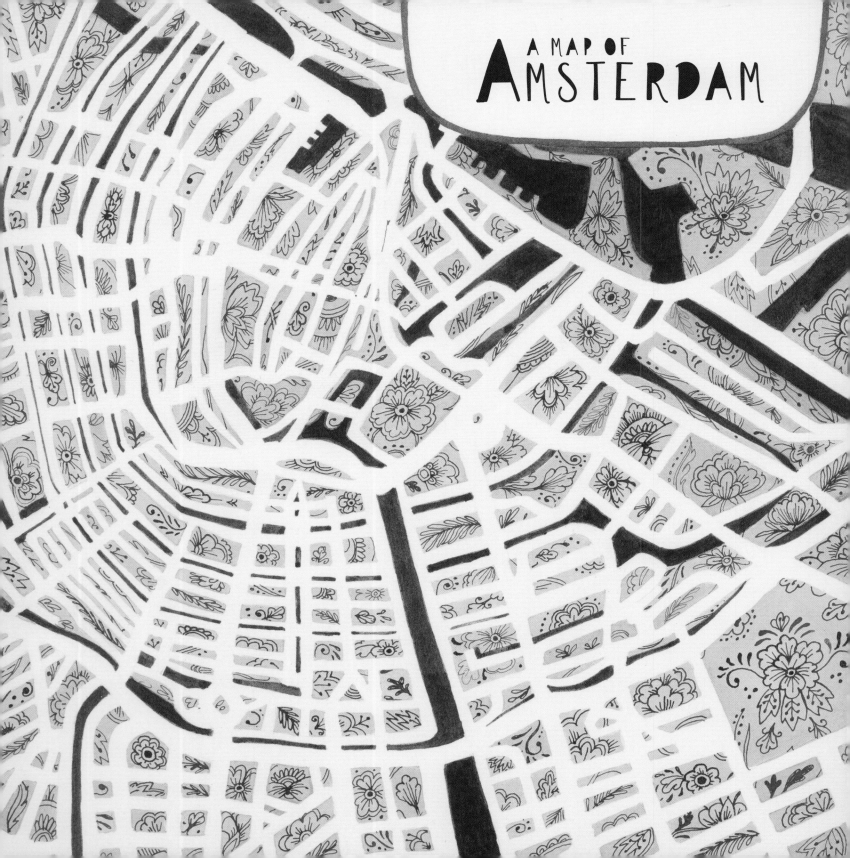

A MAP OF
AMSTERDAM

- OVER TO YOU -

When deciding on what place to map, instead of concentrating on the main geographical features, look carefully instead at the shapes created by the spaces in between them and make your choice based on this.

There should be enough interesting space in the area to give you the scope to make an eye-catching design. Older cities have built up organically, so often have unconventional negative spaces, compared with new towns and cities designed by town planners who tend to use grid systems that create a more geometric look.

Another, different effect can be created by mapping the negative space of a rural area that has less positive space. Fewer landmarks and roads will give you a large surface area to work with on your negative-space design.

Consider starting to draw your map in the center of the page and work outward, using an existing map or online reference to help you. This will help you with getting the scale and proportions accurate.

With a negative-space map, the main features should be a neutral color, such as black or white, so they stand out against the detail in the negative space, and do not distract from it.

Experiment with different ways to present the negative space. You could plan a conceptual design, using imagery, patterns, or colors that reflect the character of your chosen place. You could alternatively simply use a block color. You could cut the negative space out completely using a sharp craft knife.

ARCHITECTURAL MAPS

Architectural maps are technical drawings that describe the plan of a building. They generally follow established conventions and, like many maps, rely on a standard set of symbols to communicate features. Historically, these maps were drawn in pencil or pen on graph paper, but computer software has since enabled architects to produce slick 3-D digital versions and the art of the hand-drawn floor plan has been somewhat lost.

A floor plan, which I concentrate on here, is a basic diagram mapping the spaces within a single story of a building, seen from above. It can show walls, windows, and doors, alongside fittings and furniture. Sometimes these maps include hand-written notes, references, and keys for clarity.

There is something about the precision and clarity of architectural drawings that I find very appealing. Using graph paper, I enjoyed experimenting with the format to create my own fantasy home (overleaf). I began by making a list of necessities—kitchens, bathrooms, bedrooms, and living space—and then added a wish list of luxuries: spas, wine cellars, spiral staircases, and woodburning stoves. Not to mention, of course, somewhere to play ping-pong.

I researched architectural symbols online and then sketched out a floor plan of my new home, including all the elements of my necessity list and wish list. Placement of windows, doors, and staircases had to be considered alongside the practicalities of grouping certain rooms together—kitchens next to recycling areas and bathrooms near bedrooms. As an artist, I found it an interesting exercise in mapping with both logic and imagination.

- OVER TO YOU -

Architectural maps are based on logical planning, so consider making a list before you put pencil to paper. What rooms do you need and how many?

Add to your list the necessary features (such as walls and windows), as well as any luxury ones you would like. Think about what symbols you need in order to show all these features on your map, and create a key. Use the standard architectural symbols, as seen on my own map (overleaf), to help you (or look them up online).

Using the graph paper template at the back of the book, sketch out in pencil your floor plan—the shape of your rooms, the living and outdoor spaces. Rulers and protractors will be helpful for getting scale and proportions accurate and consistent.

As you are designing the floor plan, consider your list of features and where these should go in relation to each other (a fireplace, for example, should not be placed next to a door). Use the symbols from your key to draw these features in their final position.

MAP KEY (SEE OVERLEAF)

1. Kitchen	13. Light well and staircase to roof terrace	23. Courtyard
2. Wine cellar	14. Second bedroom	24. Planter
3. Utility room	15. Second en suite	25. Fire basket
4. Light well	16. Lounge	26. Fountain
5. Media/ping-pong room	17. Veranda	27. Entry gate
6. Master bedroom	18. Outdoor kitchen	28. Recycling and compost
7. Storage	19. Spa	29. Back entrance
8. En suite bathroom	20. Access to lake and grounds	A. Beds
9. Art studio	21. Herb garden	B. Sofas
10. Cloakroom and storage	22. Decking	C. Chairs
11. Entrance hall		D. Baths
12. Foyer		E. Sinks

F. Toilets
G. Oven
H. Fireplace
I. Outdoor fireplace
J. Woodburning stove
K. Outdoor table
L. Appliances
M. Table
N. Ping-pong table
O. Media system

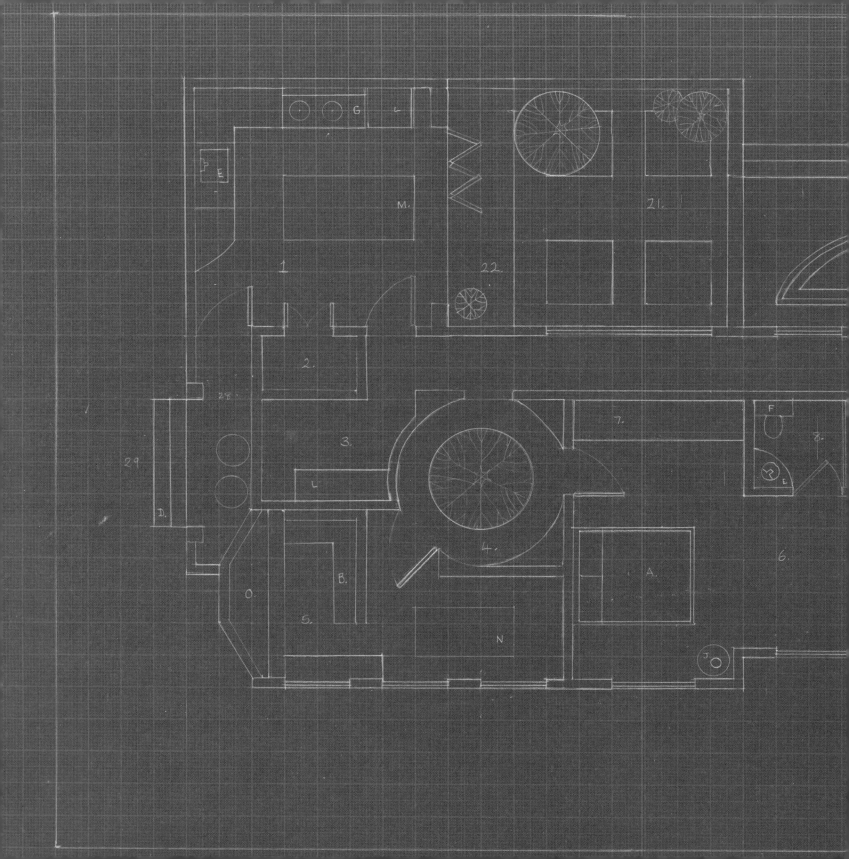

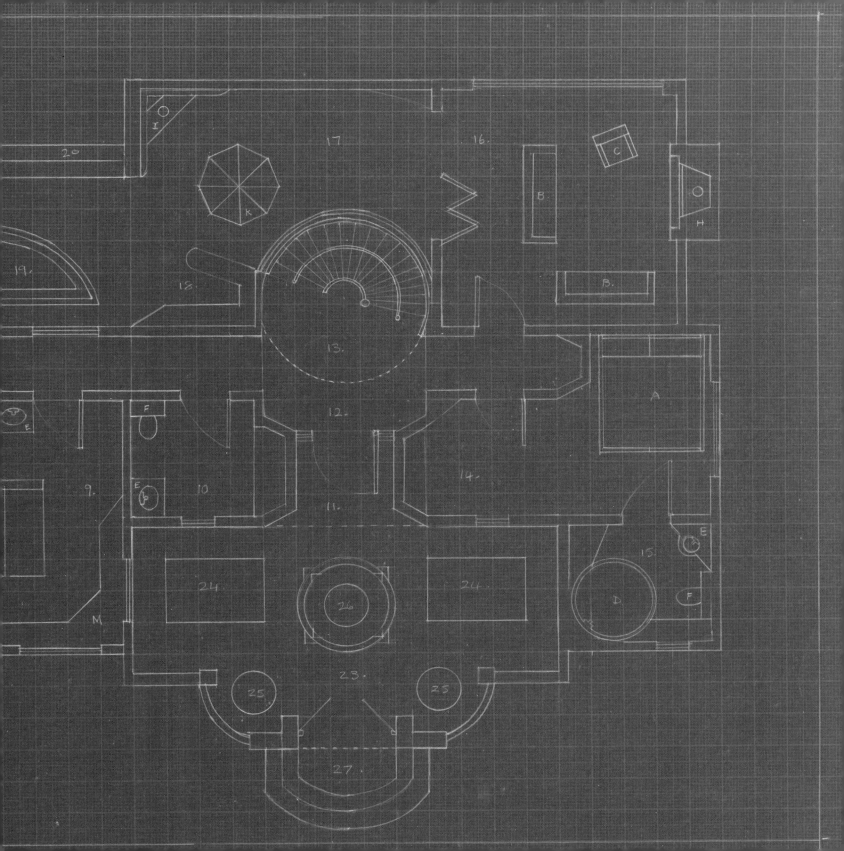

PLATFORM-GAME MAPS

The 1980s: a decade of hot summers, cold wars, Madonna, and legwarmers, when no self-respecting teenager would be without a handheld console, head buried in *Pac-Man* or *Super Mario*. These original platform games gave us some of the first examples of how a landscape can be electronically mapped, and they provide an enduringly appealing aesthetic for maps today.

The locations of the original platform games were created with pixelated tiles, and the geography, characters, and features always had a bright, square-edged quality about them. The environment in the original arcade game *Pac-Man* is mapped in a basic manner with no geographical features but very distinct demarcations of space. Neon-blue borderlines show the edges and contours of the maze through which players must navigate Pac-Man, gobbling up dots and avoiding the ghostly enemies. You can create a charmingly retro map inspired by this style.

Some of the original platform games landed players in an environment where they collided with danger, collected bounty, or found a way to move to the next level—another platform, with another mapped environment. The worlds in *Super Mario* are more diverse and numerous than in *Pac-Man*. Players must navigate the Mario Brothers through a pixelated underground, desert, or treetop landscape as they attempt to rescue Princess Toadstool and save the Mushroom Kingdom, invaded by the evil Koopa tribe. These landscapes are based on a grid format, and often use symbolic color—golden tan for deserts, white for arctic snow, and green for plains. Further symbols add detail, and these repeated motifs make the geography clear and familiar to players. For example, the same symbol for "tree" is repeated over and over to represent forests. The meetings of land and water are marked in heavy black. Players navigate the protagonists vertically and horizontally along straight roads, which are interrupted periodically by hazards and bounty—features inherent to a gaming landscape.

COMBINING THE OLD WITH THE NEW

Retro gaming iconography has been used imaginatively by a number of artists as a language with which to create maps. In 2010, CDH, an Australian street artist, used the familiar visual vocabulary of *Pac-Man* to create a walking guide to Melbourne's street art. Pasted up on walls throughout the city, his work maps out the city in the form of a maze, with Pac-Man himself taking the lead, eating his way along the dotted route.

My own map (overleaf) uses some of the *Super Mario* style, but I've created my own personal gamescape. Using graph paper and bright colors, it's a clearly hand-painted version of a digital world. Everything is based around the pixel and designed on graph paper. It is all bright and clean-edged, to evoke that old-school style.

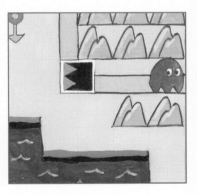

My map includes geographical features in the form of mountains, forests, and flower-dotted plains. There are whale-infested rivers and a waving octopus in the sea.

My characters are Arthurian knights in armor, doing what knights in armor do: looking for the Holy Grail, running away from dragons, and rescuing princesses.

I also included a rogue red ghost, escaped from a *Pac-Man* game and trying to find his way home.

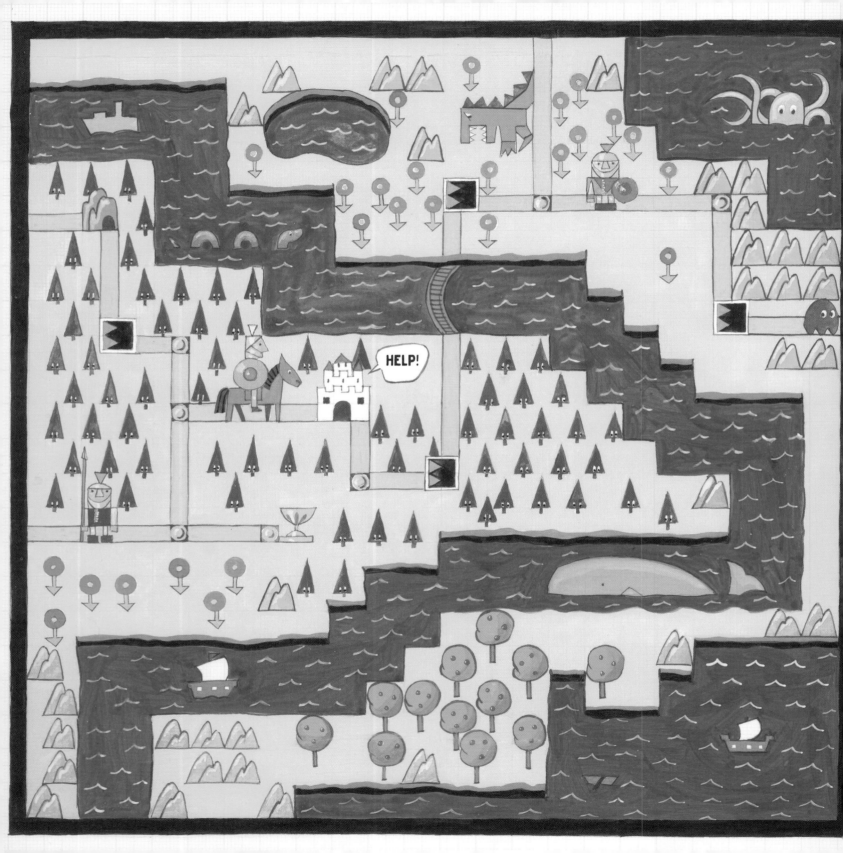

− OVER TO YOU −

Decide on the theme of your video game (for example, "desert island"), then use the graph paper at the back of this book to help you draw the areas of landmass on your pixelated landscape. Generally, boundaries tend to be fairly straight and with right angles; however they do have some flexibility to them, so use the lines on the graph paper as a rough guide.

Now add inland water areas to your landmass. These could be rivers, lakes, ponds, or canals. Refer to my own map for examples of how to use the graph paper to create the right shapes.

Use a ruler and follow the graph lines to create straight roads running horizontally and vertically to each other. You could sometimes make the roads cross, or make them stop mid-country, or you could run the road over a river and add a bridge.

You can create a variety of tile-size symbols to show different areas of geography, like forests or mountains.

The geographical features that comprise your landscape should fit within the squares on the grid and be simple enough to be easily repeatable. You could create a blue glacial mountain tile for a snowy landscape, or palm tree tile for a jungle.

Your characters also need to be designed within the grid squares. I created characters that were mostly made of straight lines, but you can also use curved lines like Pac-Man and his ghosts.

What features will your character collect or collide with? My Arthurian knights are collecting gold coins and the Holy Grail, but your bounty might be candy bars or bottles of wine.

I also added a purely geometric symbol tile on the road system to show the exit to another platform, as you would find in *Super Mario* games.

Use bright, flat colors to stay true to the video-game style. I used gouache paint, but you could create the same effect using felt-tip pens. Remember to keep all the colors consistent for each feature type.

To finish, I gave the landmass edges and the frame of the map itself a strong black line for that authentic platform game feel. Game over.

ABI DAKER

Abi Daker is a British illustrator who lives and works in Cyprus.

She specializes in hand-drawn maps, cityscapes, and architectural drawings. You can find more of her work online via her website: www.abigaildaker.com.

Q: What is it that you enjoy about creating hand-drawn maps?

The most intriguing thing about working on hand-drawn maps is discovering more about the country or city the map is focused on. Many of the places I have drawn were not ones I knew in much detail before I was commissioned to work on them and I've found that each country or city is endlessly fascinating.

Q: Can you tell us about your map of Africa, shown here?

The map of Africa was commissioned as a gift by a private client and so features a number of locations that were significant to them. I drew the compass roses by sketching the area out and then coloring around it before erasing the pencil, so the lines were created by the negative space; this gave it a soft, slightly aged feel, which I thought would work well with the subject.

Q: What tips would you give to people interested in creating their own hand-drawn maps?

Research the area you're working on beforehand; this will help give you a good idea of the character of the place and help you choose which features to include. With most of my maps, the pencil sketch stage takes the longest; I usually do a rough layout, then a more detailed sketch, and then a further pencil draft if needed. I find this approach improves the quality of the finished artwork.

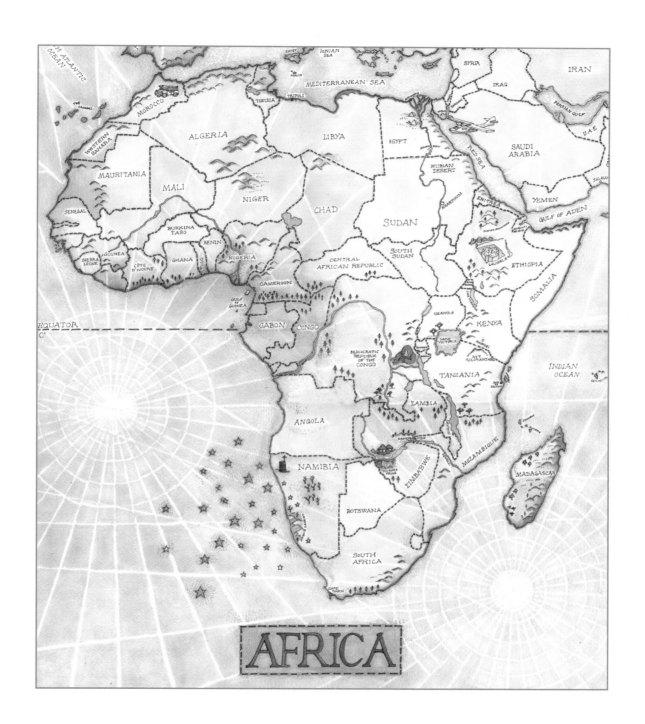

AFRICA

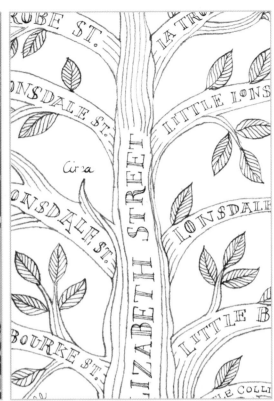
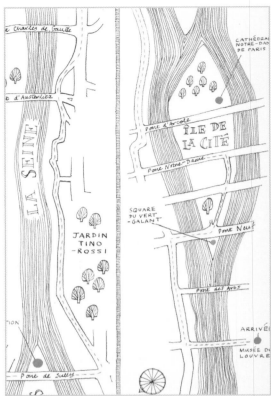
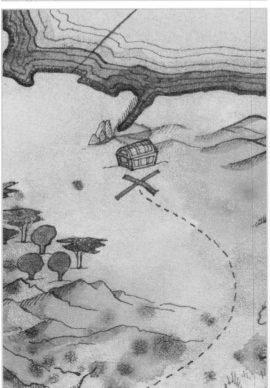

SECTION 3
MAPS OF PLACES

TRANSIT MAPS: GOING UNDERGROUND

Subways, metros, tubes . . . whatever you call them, the underground transit systems that rumble beneath the world's major cities are rich locations for mapmaking. So, for your next map, descend into the dark world of winding staircases, subterranean halls, and mysterious tunnels, where warm air strangely gusts and sooty mice hurry between the electric rails.

The London Underground opened in 1863 and now transports over a billion passengers a year. These passengers must understand how to navigate in this underground world that they can physically experience only as a series of isolated, subterranean tunnels, invisible from above ground.

The first map to use the iconic diagrammatic format we see today was created by Harry Beck in 1933. Its groundbreaking design shows no geographic locations; instead, it focuses purely on the basic relative positions of stations and lines. The map has since been developed, but it keeps generally the same stylized format, and this approach has been widely adopted for other network maps internationally.

SUBVERTING THE SUBWAY

As well as finding creative ways to depict an underground system, you could adapt an existing transit map to create something unexpected. These maps have a rich visual language, and their iconic style can be adapted for other, less literal purposes. A good example of a subverted subway map comes from Simon Patterson—a member of the Young British Artists (the YBAs), who first emerged in the late 1980s in the *Freeze* exhibition organized by Damien Hirst in London. Concentrating on text in his 1992 *The Great Bear* tube map, Patterson replaces the names of stations with those of people— from philosophers to explorers, journalists to comedians, soccer players to saints, and Chinese scholars to French kings. As a viewer, you try to make sense of the map— making connections between "stations" on a particular line or associations between the person represented and the station name it has replaced—but apparently the artist's aim was simply to disrupt the familiar and juxtapose different paths of knowledge to form something that is greater than the sum of its parts.

PICTURES NOT WORDS

For my own transit map, I opted to depict the London Underground, taking my inspiration from a transit map of the Paris Métro system with no text at all, created by leading French graphic design duo Antoine Audiau and Manuel Warosz.

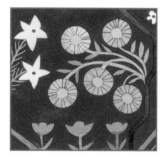

Like their Paris Métro, my map is based on the simple structure of Beck's London design, but the addition of stylized botanical elements and iconic structures of the London skyline reminds us of all that is above ground.

The bold colors and clean background are in direct contrast to the dark and dust of the subway. I planted a subtle compass rose in the bottom right corner, in keeping with my botanical designs.

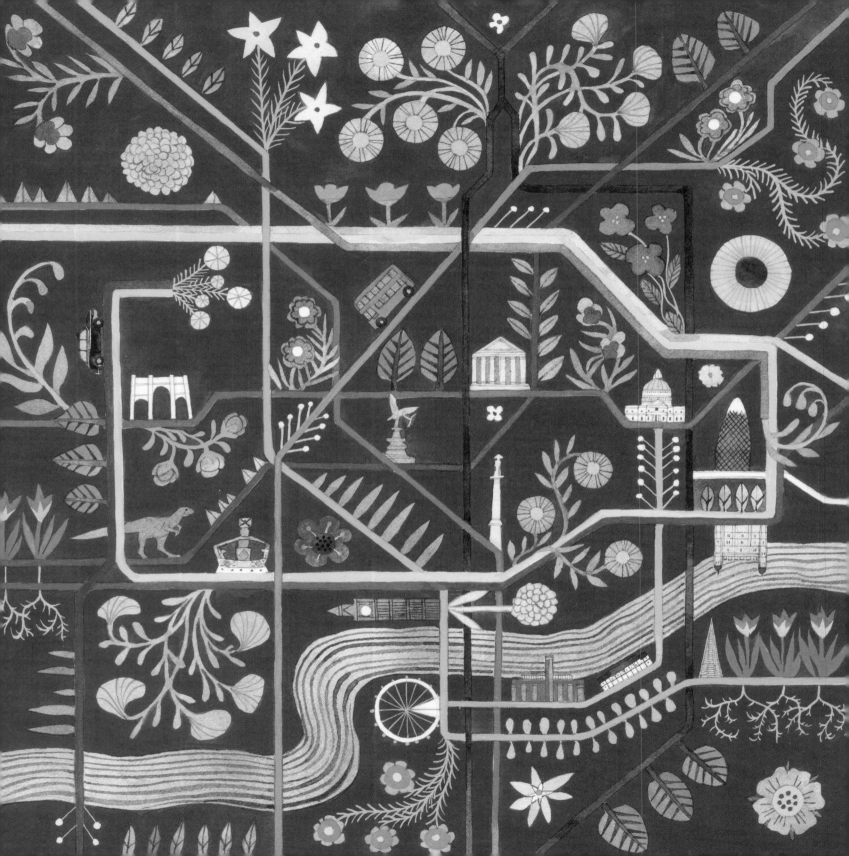

— OVER TO YOU —

It is best to choose a transit system in an area that you've used yourself or that you are very familiar with, both for accuracy and to give you plenty of material to work from. Use an existing map as your base and plan some ideas of how to customize it.

When creating your own design of the network, you could use the colors traditionally used for each line (as I did in my map opposite), or you could give each its own distinct pattern (see the Business Cards project on pages 148–151 for an example). The shape of each route as shown on transit maps is often identifiable to users, so instead of using different colors, you could use a single color for the whole network.

Think about what details you wish to include in your map and how you would like them to appear. For example, you could mark the correct positions of stations on each line but then alter the names of each station based on a theme, such as a movie or sport.

Alternatively, you could create picture icons that reflect each station, for example an illustration of Queen Victoria for Victoria Station in London. Another idea to try is to add visual references to the iconic buildings above ground that the network corresponds to, as I have done. They don't have to be accurately placed but could helpfully represent which stations serve notable venues or famous places.

You could create a transit map that subverts its use entirely. Keeping the lines in their familiar places, turn them into trees growing vertically and horizontally, or make them into a flower garden to contrast with the gloom and dust of the tunnels.

If your map contains text, what style of lettering will you use? Remember the different impressions you can create by using either serif, cursive, or sans serif fonts (see pages 16–23).

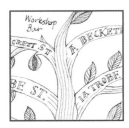

TREE MAPS

Maps using trees and branches as their structure are usually associated with genealogy or the mapping of ideas, but this technique can also be used to map locations. Tree maps are a useful way to show a main road or central artery, with smaller streets or areas as offshoots.

Liam Roberts's illustrated map *The Tree of Brixton Pubs and Cafés*, created in 2012, shows a stylized tree growing from the banks of the River Thames in London. The tree trunk is labeled Brixton High Street and each of the offshoot branches is given the name of a corresponding smaller street. The tree is covered with leaves, tiny birds, nests, and a few playful squirrels. Fruit of different kinds covers the boughs like a box of jellied candies. The pubs and cafés of Brixton (The Queen's Head, Canterbury Arms, White Horse) are all identified along the branches. Liam makes sure we know it's a map, with a compass rose and a flamboyant cartouche flying jauntily at the bottom.

MAPPING HISTORY

A historic example of a tree map is J. R. Wheeler's 1851 chart of the location, origin, and date of establishment of every county in North Carolina. A grand old tree, it's fairly realistic in style, with a broad trunk detailing all the original counties in the state. Offshoots from here become green leafy boughs showing later county names and dates. Some of these were clearly historic at the time, as Wheeler tells us that "Counties marked with a * do not now exist but are laid down to show the root from whence older counties spring."

Both Roberts's 2012 map and Wheeler's 1851 chart show very clearly the dates when they were created. The cartographers document an area at a particular point in time, fully aware that things are likely to change in due course. The North Carolinian counties could be renamed, as historically they have been, and more branches would need to be added to the tree. The pubs and cafés of Brixton High Street will close or change as it becomes subject to gentrification, for example.

MAPPING THE CITY

My own tree map is of cool places near Elizabeth Street in the gridded streets of Melbourne, Australia. I took Liam Roberts's idea as a fun and different way to map this street area. Elizabeth Street is based around a grid system, making this kind of mapping easier to do. The central road lends itself to the idea of a trunk with the arterial roads acting as boughs. Many of the places I wanted to map could be grouped under the headings of bars and cafés, so I gave these specific symbols. Other cool places and activities not associated with beer or coffee are simply labeled with text: get lost among the curiosities, the stuffed ravens, and preserved crocodiles at Wunderkammer; lunch on steamed Chinese buns and hot soy milk at Wonderbao. Like Liam Roberts, I chose to use a simplified style, creating a tree with individually drawn leaves for a decorative rather than realistic effect.

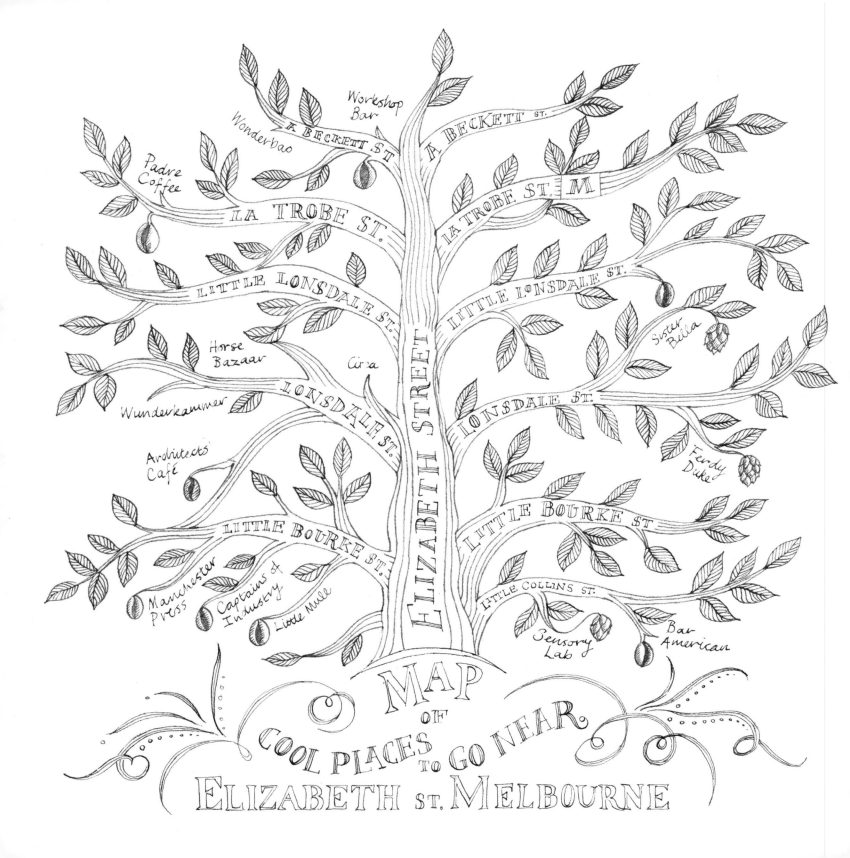

— OVER TO YOU —

Choose an area you would like to map, preferably a place
with a main road that has plenty of arterial roads coming
off it. Draw the main road as a tree trunk.

Consider where to place a cartouche on your design.
I set mine underneath the tree, in its roots.

Draw the arterial roads as boughs shooting off from
the main trunk. Try to place each road/bough in the
correct geographical position in relation to the others.
Use your own hand lettering to label all the streets.

Add any notable places on your tree, using text or symbols.
Depending on your location, you may wish to map pubs and
cafés, or useful places like grocery stores or laundromats.

Your map symbols could relate to trees in
general, like Roberts's fruits, or could be iconic of
the notable places themselves, such as the coffee
beans I have used to symbolize cafés.

For a realistic look, you could add a general mass of leaves
behind each bough, as you can see in J. R. Wheeler's
representation. For a more stylized look, draw individual
leaves on each bough as you can see in my own tree map.

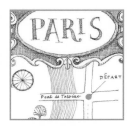

RIBBON MAPS

Ribbon maps are a way of mapping the path of a journey while leaving out any surrounding areas or extraneous information. This focus on a single route means that they tend to be created in a long, narrow format, which is sometimes rolled into a scroll or sectioned off into parts displayed next to each other.

The earliest ribbon maps can be found drawn on the bottom of ancient Egyptian coffins, showing the deceased the way to the afterlife. There is a beautiful later example of a ribbon map by 13th-century Benedictine monk and mapmaker Matthew Paris, who mapped the pilgrimage route from London to Jerusalem. A glamorous map for any pilgrim to take with them, it's colored in rich blues and gold leaf. The winding journey runs vertically, and any towns along the road are illustrated in miniature detail and labeled in neat red script.

OGILBY'S RIBBONS

My own map of a walk in Paris (from the Pont de Tolbiac to the Louvre) was inspired by the work of John Ogilby. The heyday of the ribbon map was the 17th century, when road systems were becoming more established. The British postal service, the Royal Mail, was created in 1635, and postboys sped across the countryside on horses delivering letters. Maps were becoming more necessary as travel became more accessible. Step up Ogilby, an eccentric Scottish entrepreneur and dancer-turned-cartographer. His maps of post roads are designed to look like strips of unfurling scrolls and take the reader downward from one town to the next as if you are only looking ahead. Compass roses appear along the route to show slight changes of direction. Cartouches are decorative and original, with a fairly random choice of mythological figures waving from the sidelines.

My own map (overleaf) has a modern, clean look, with simple symbols.

I created a basic, unannotated compass rose.

My curlicued cartouche with serif hand lettering gives a nod to the past.

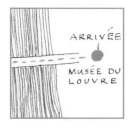

A clear red dotted line shows the route. Two bold red dots identify the start and finsh.

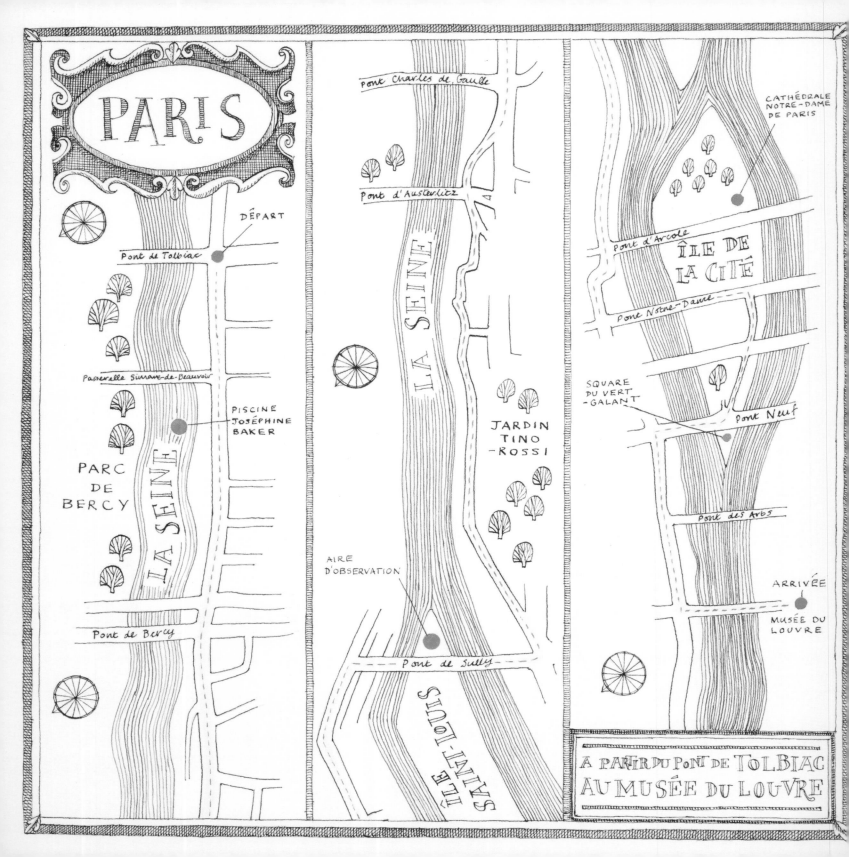

- OVER TO YOU -

Plan a walk in your local area, preferably one with a route that's relatively straight from its start point to its destination. Then get outside and walk it.

Walk the route yourself, making little sketches and notes of the main features you come across. Mark and name roads and rivers that cross your path, and take note of trees and parks that border them. These will become the symbols on your map.

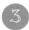

Once you have planned, walked, and collected notes from your routes, you can start creating your map. Start by dividing your page into vertical sections, as I have in my map. These sections will form the strips on which you will map the route.

Start at the top of the far-left section. Draw the pathway down to the bottom of this section, and continue from the top of the next. Repeat this until you reach the bottom of your last section, and the end of your walk.

Draw in the roads and rivers that crossed your path and label them. These help to give the reader a sense of the geography of the area.

Use your sketches to help you add decorative features to the map in relation to the route. And, of course, feel free to add compasses for orientation, and cartouches for extra decoration.

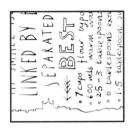

ANNOTATED MAPS

As we know, places can be described with both symbols and labels on a map. But often these simple elements are only a very small part of the story. What about the extra information—such as historical details or personal experiences of a place? Locations are always more than the sum of their geographical features—adding notes can give map readers a much richer understanding.

Becky Cooper's 2013 collaborative art project *Mapping Manhattan: A Love (and Sometimes Hate) Story in Maps by 75 New Yorkers* is a collection of annotated maps by people who live there. Becky printed out a basic outline of the island, with Central Park sitting squarely in the middle, and gave them to strangers ranging from fashion models to down-and-outs. She asked them to map what was important to them and send it back to her. The results became a book of maps full of stories, sketches, and personalities. Some mapped a life in a few simple sentences. Some mapped where gloves were lost. Or where love was lost and "threesomes with old men" averted! Each map is fundamentally identical but each shows Manhattan in a totally different light.

STRETCHING THE IMAGINATION

Annotated maps can be of imagined places too. Cartographer-artist Adam Dant meticulously maps the real location of Shoreditch in London with both illustration and annotation, but his futuristic *An Historical Guide to Shoreditch and How to Visit the Ruins* imagines how it might be mapped in the year 3000. It appears to be the only place to have survived an apocalyptic meltdown of civilization and is notated with "historic" details, alongside portraits and descriptions of notable figures from the imagined previous 1,000 years.

A VENETIAN EXPERIENCE

My own map describes Venice, and includes more than merely geographical features. I think narratives can be as important as the physical features themselves. In my map I gave myself enough space to tell my own stories of being there (ice cream in a myriad of flavors, a romantic gondola ride) as well as those of others through the centuries. Each story is told in a different lettering style to contrast it with the one before and after and is placed above the corresponding area. By focusing the design on the skyline itself, rather than the labyrinth of dark passages and canals, I gave myself plenty of space to include all the annotations.

– OVER TO YOU –

≫ 1 ≪

To make an annotated map like mine, draw the skyline, either of a place you know or one in your imagination. Skylines are an unusual view for a map because they offer a side view rather than a bird's-eye view.

≫ 2 ≪

Create a list of impressions, memories, notable facts, interesting historical information, anything that can be used to annotate your skyline.

≫ 3 ≪

Label any important places and add anecdotes, descriptions, personal opinions, historical details, or song lyrics you connect with the place.

≫ 4 ≪

After each section of writing, think about changing the lettering styles a little to differentiate it from what comes before and after. Make your letters wider or longer, serif or sans, whatever best suits your content.

PARLA INGLESE?

VENICE IS LIKE EATING
AN ENTIRE BOX of CHOCOLATE
LIQUEURS IN ONE GO — TRUMAN CAPOTE

← LAGOON
WE TAKE FERRIES + VISIT:

BURANO: COLOURFUL HOUSES
TORCELLO: ABANDONED
MURANO: GLASS
SAN MICHELE: CEMETERY
MAZZORBO: SLEEPY
LAZZARETTO NUOVO: OLD QUARANTINE
SAN LAZZARO DEGL' ARMENI: MONASTERY
SANT'ERASMO: I DON'T KNOW
LE VIGNOLE: I DON'T KNOW EITHER...

FLOODS: SPRING + AUTMN

Venice is built on marshland on wooden piles
of alder trees sunk deep in the mud.
IT SINKS 1-2 MMS EVERY YEAR

117 SMALL ISLANDS
LINKED BY BRIDGES
SEPARATED BY CANALS.

← BEST PIZZA

○ 7 cups flour typo 00
○ 600 mls warm water
○ 2.5-3 tablespoons fresh yeast
○ 6 tablespoons extra virgin olive oil.
○ 1.5 tablespoons salt
○ 2 tablespoons sugar

GRAZIE MILLE!
ACCETTATE CARTE DI CREDITO?
PREGO
CIAO CIAO
BUONA NOTTE

LOCATION: DEPARTMENT STORE
PERP.: MALE
HAIR: BROWN
HEIGHT: 115 CMS
AGE: ABOUT SIX.
(I FROWN AT HIS MOTHER WHO IGNORES ME....)

← **BRIDGE OF SIGHS**
Kiss under the bridge in a gondola at sunset when the bells of St Mark's toll. Eternal love is yours.

← **DOGE'S PALACE**

← **ST MARK'S BASILICA**

ST. MARK'S SQUARE
← TOURISTS + PIGEONS

← **ST MARK'S BELL TOWER**
THE NONA BELL = MIDDAY.
THE MARANGONA = MORNING + EVENING
THE TROTTERIA = HURRY TO THE COUNCIL!
THE PREGADI = MEETING OF THE SENATE
THE MALEFICIO = EXECUTIONS.

1756 **GIACOMO CASANOVA**
'the greatest lover in history escaped the prison in the Doge's Palace over the roofs of Venice.'

1609 **GALILEO GALILEI**
demonstrates the telescope to the Doge from the tower.

← **GONDOLAS**
He takes us down the cool, dark waterways and gently sings in time to the soft dip and splash of the pole.

'O SOLE MIO STA NFRONTE A TE
'O SOLE, 'O SOLE MIO, STA NFRONTE A TE,
STA NFRONTE A TE!

GELATERIA
• FIOR DI LATTE
• CIOCCOLATO
• LIMONE
• PISTACIO

← **BASILICA DI SANTA MARIA DELLA SALUTE.**
1630 VENICE GOT THE BLACK DEATH.
THE REPUBLIC BUILT THE CHURCH AS AN OFFERING TO MARY. KNOWN AS A 'PLAGUE CHURCH'!
A THIRD OF THE PEOPLE DIED.

← **HARBOUR**
happy bouncing boats in the Italian sunshine.
ARRIVEDERCI MI AMIGO!

VENICE

DUNGEON MAPS

Dungeons and Dragons—it's the tabletop fantasy role-playing game that has been played by wannabe elves since the 1970s and is stereotypically associated with the unmistakable whiff of an adolescent's bedroom. Regardless, the game has been enjoyed by millions for over forty years. It's creative, interactive, and, despite the occasional moral panic over alleged *D&D*-induced satanic worship, probably good, harmless fun.

Each player takes on the role of a character who embarks on an imaginary adventure in a world peopled with dwarves and trolls. It's Middle-earth, Jim, but not as we know it! Players collect treasure, fight monsters, and work together to gain power. The dungeon map is integral to the game, and is used by the Dungeon Master (DM) who oversees all, often creating the story itself. It is the DM who describes a location to the other players and they, as a party, make decisions about their next move. The resulting actions are decided on by the roll of a dice.

Traditionally, the game location (let's call it the dungeon for the sake of ease) is mapped out simply on graph paper. Early game sets provided simple blue maps with a standard set of symbols. Since then, however, it has become acceptable for each DM to create their own set. Of course, he will additionally mark where monsters lurk in the shadows, enchanted gold is hidden in caves, and secrets await to be uncovered from behind moth-eaten tapestries.

Mapmaking has now become more sophisticated and it's possible to create full-color digital versions, but there is an argument to be had that the old-school hand-drawn maps allow greater room for player imagination and storytelling skills to shine.

My own map is inspired by the cartography style of Dyson Logos, who has a huge following in the *Dungeons and Dragons* gaming world. There is certainly no lack of sophistication about his maps. He creates labyrinthine locations with heavy, darkened walls and meticulous cross-hatching. His maps are beautiful images in their own right,

but the game always comes first. Every castle has two exits to prevent dead-end ambushes, using multiple subterranean layers, reminding players that this is no mere 2-D board game.

Similarly, when drawing your own map, you should keep the gameplay central to your design. Think about constructing an adventure first and considering how the location can facilitate this for the players. Make sure, like Dyson, you add places of mystery or of danger and that, to keep the storytelling action interesting, you add a variety of different ground levels.

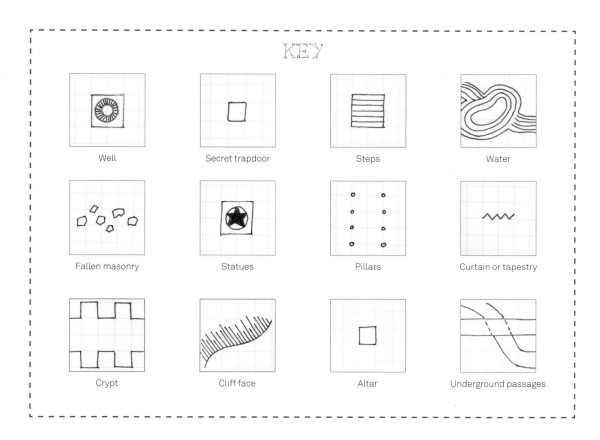

KEY

Well	Secret trapdoor	Steps	Water
Fallen masonry	Statues	Pillars	Curtain or tapestry
Crypt	Cliff face	Altar	Underground passages

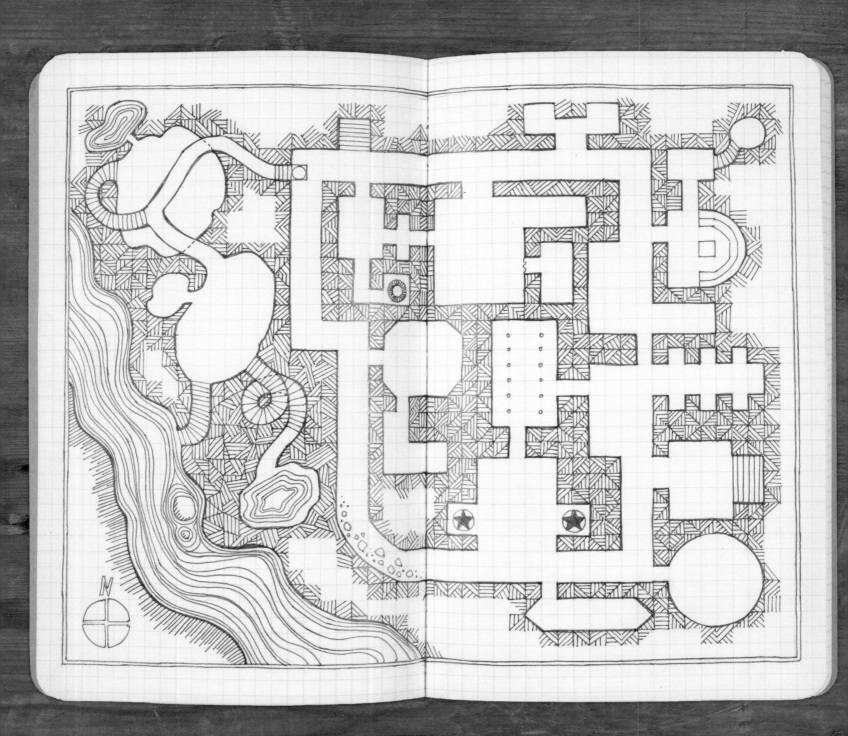

– OVER TO YOU –

Start by listing what you would like your players to experience inside the dungeon. For instance, it is good for gameplay to have drapes or pillars for characters or adversaries to hide behind, or rivers, steps, and trapdoors that can be used for surprise entrances or quick escapes within the dungeon.

Places like crypts or rooms with mysterious altars or passages with fallen masonry can also help create an atmospheric or challenging environment where a good story could be told.

Using the graph paper at the back of this book, make an initial external outline of your dungeon, then create rooms and chambers of different shapes and sizes. Using the lines on the graph paper as guides, create rectangular and circular forms that are connected to each other through a series of passages.

Think about introducing different levels to your map to help with more dynamic storytelling. Use the standard symbol in my key (see page 85) to represent underground passages.

Draw freehand to create more informal shapes like caves or pools. Adding dark shading to walls and the boundaries of features will make the map easier to read. Cross-hatching in the empty spaces outside the dungeon adds contrast. If you like, you could also add color to your map, but keep the color of particular areas consistent.

Either research standard *D&D* map symbols or create your own to add jeopardy and adventure to your game map. You could also use the map symbols in my key for inspiration.

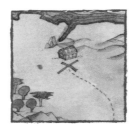

TREASURE MAPS

Pirates buried treasure (at least on one known occasion) but no historic map has ever been found. Pirate treasure maps may belong to the worlds of movies and literary fiction alone, but they still provide rich inspiration for creating sumptuous maps in this well-loved style today.

Robert Louis Stevenson's classic novel *Treasure Island* was first published in book form in 1883. His descriptions of the treasure map have been hugely influential, and introduced to popular culture the idea of "X marks the spot." Using a simple, hand-drawn style, in limited colors, Stevenson's map includes an ornate cartouche and compass and a multitude of rhumb lines (imaginary lines drawn on maritime charts to plot a ship's course in relation to a compass). It's a great example of a traditional treasure map.

MYTHICAL SECRETS

The *Mao Kun Map* from the hugely successful *Pirates of the Caribbean* movie franchise breaks many of the traditional treasure-map rules, however. It's constructed in a series of concentric brass circles that can be moved independently of each other. Once lined up correctly, it can be read. Covered in ancient Chinese script and images of junks, dragons, and astronomical details, it has no fixed points, and its "treasure" is the locations of mythical places like "The Fountain of Youth" or "The Land of the Dead." It provides wonderful inspiration for a richly decorated, antique-fantasy map.

I have used both traditional and fantasy elements in my own treasure map, which was first prepared with a coffee solution to give it an aged, foxed look.

─ OVER TO YOU ─

When drawing the outer edges of your island, vary the style of your lines, creating a rough and irregular ragged coastline. Smoother, broader lines can be used in some places to indicate straight cliffs and sandy beaches. Occasionally you could sharply indent your lines to create natural harbors and river mouths.

Add some symbols for appropriate features, such as palm trees, rain forests, volcanoes, or enigmatic rock formations. You may wish to refer to the chapter on creating symbols (pages 28–31).

Annotate your map by labeling your features and giving them names to reflect a pirate theme. Use a serif style or cursive lettering for an antique effect.

To create a fantastical effect, you could add some mythical creatures to the sea.

Add a compass rose and cartouche, lushly decorated with maritime or treasure island iconography. My cartouche shows shells and seaweed, but you could add skulls, wooden chests, or gold pieces.

Rhumb lines are one of the true indicators of a maritime chart. To create these, continue each line out from the points of your compass and across the areas of water (avoiding any landmass).

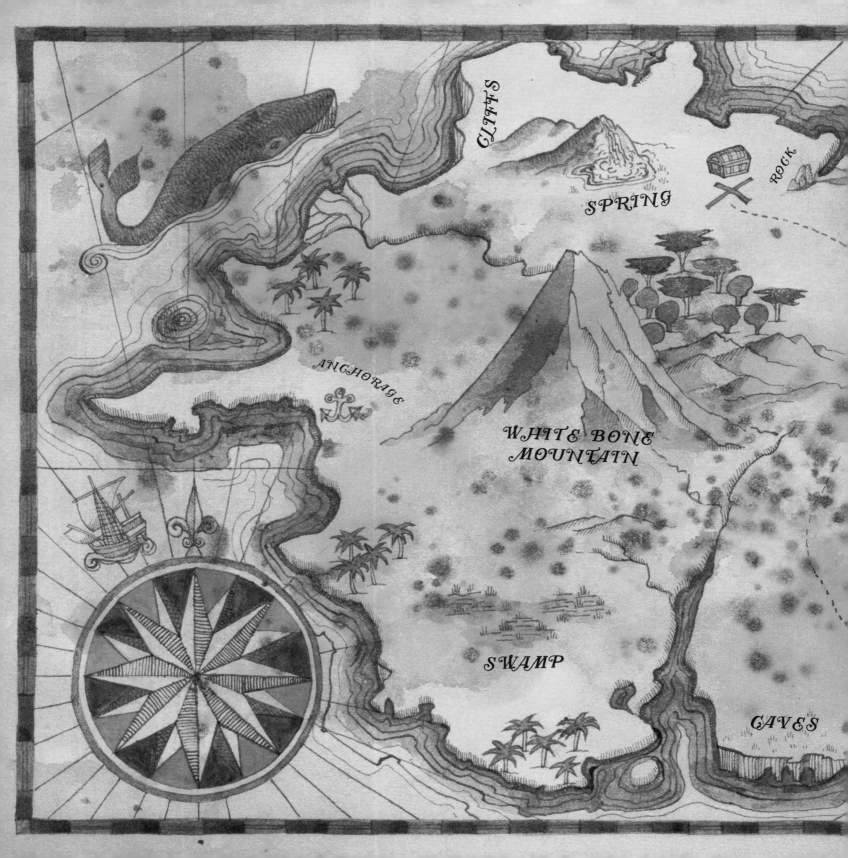

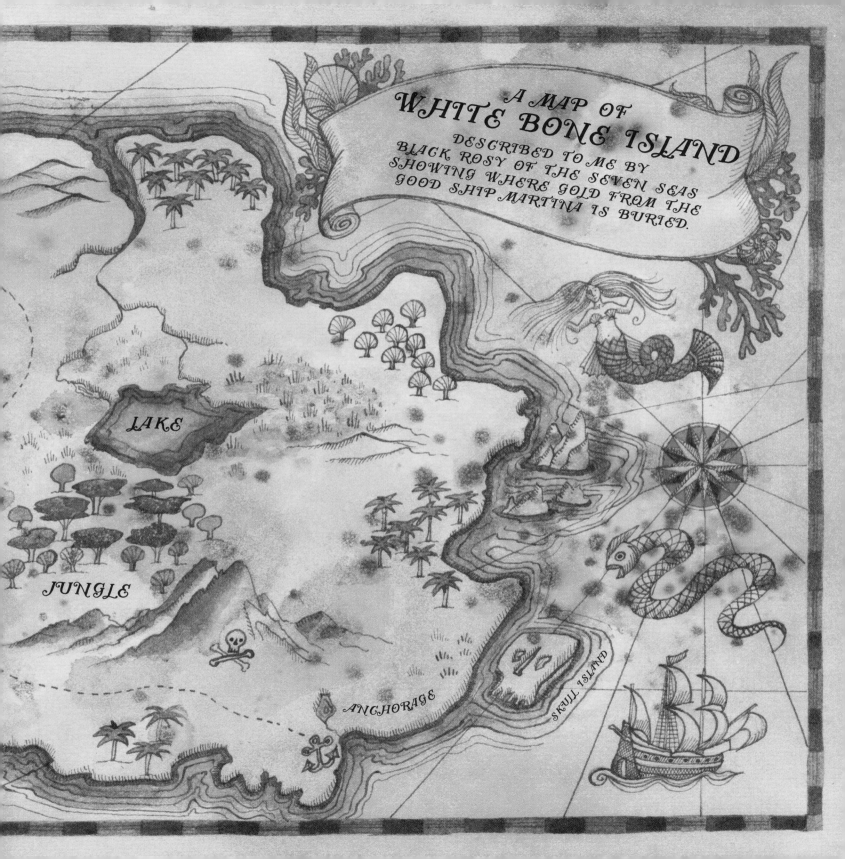

A MAP OF
WHITE BONE ISLAND
DESCRIBED TO ME BY
BLACK ROSY OF THE SEVEN SEAS
SHOWING WHERE GOLD FROM THE
GOOD SHIP MARTINA IS BURIED.

LAKE

JUNGLE

ANCHORAGE

SKULL ISLAND

ANDREW DEGRAFF

Andrew DeGraff is an artist and illustrator living and working in Maine.

His first book of maps, *Plotted: A Literary Atlas* was published in 2015 by Zest Books. Andrew continues to paint maps and illustrations for various publications and gallery shows. You can find more of his work online via his website: www.andrewdegraff.com.

Q: What is it that you enjoy about creating hand-drawn maps?

I really enjoy having a fixed set of data to play with. It's like building with a set of blocks: You can build anything you want with those blocks, but you can't make more blocks. Part of the fun of any artistic or design challenge is the restrictions you have to deal with and work through. Painting maps almost feels more like creating a puzzle than a painting.

Q: Can you tell us about your *Pete Dye Trail* map, shown here?

I'm a big fan of American roadside signage and nostalgic typography, and this map presented me with a chance to combine those elements into a playful tour of some golf courses in Indiana. The courses have great names as well, so it was easy to infuse a little humor and whimsy, and make it feel more like a fun mini-golf course.

Q: What tips would you give to people interested in creating their own hand-drawn maps?

I think it's important not to get too stuffy. We are in a world where we have incredibly accurate maps in our pockets all the time, and all that accuracy can feel fairly cold. The atmosphere, the time, the mood, the music of a place—and even your own artistic mistakes—can evoke a more in-depth and enjoyable sensory experience. I think a really good hand-drawn map shouldn't just be a handy reference to a place—it should also inspire you to go there.

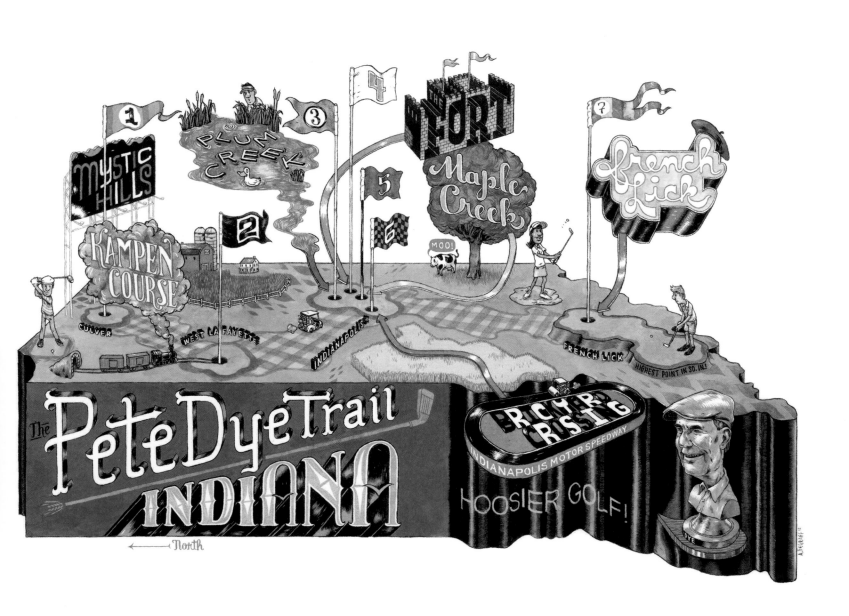

ANDREW DEGRAFF 93

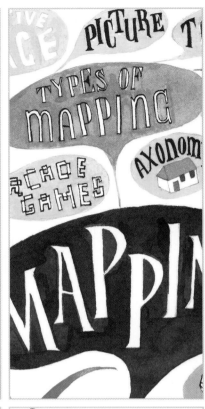

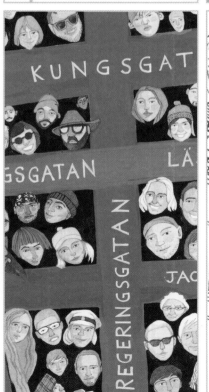

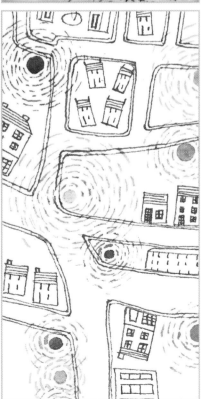

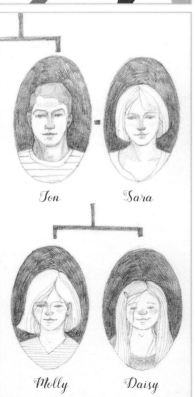

SECTION 4
MAPS OF IDEAS

PHRENOLOGY MAPS

Phrenology was the faux-science of determining an individual's character by measuring the areas on the person's skull that corresponded with a particular set of personality traits. The distinctive charts or models of heads segmented into parts, showing these characteristics with both text and pictures, are still familiar today, though phrenology's heyday was way back in the early 19th century.

First created by a German doctor, Franz Joseph Gall, in 1796, before the birth of psychiatry, phrenology maps were surprisingly prescient in suggesting that parts of the brain were responsible for specific behavior. However, the phrenology system itself was not based on any proven fact and was occasionally deployed to support problematic claims regarding the inferior mental capacity of women and people of color. Phrenologists also believed that particular areas of the brain became enlarged when a corresponding behavior was repeated. This they believed would naturally force the skull outward, and feeling for these bumps would allow you to read the true character of your subject—an approach that is no longer considered scientific.

THE ART OF PHRENOLOGY

Phrenology maps are familiar starting points for artists and illustrators. Jeffrey Fisher's illustration for *Time* magazine, called *Known Unknowns*, shows the flat profile of a head segmented into parts, in the style of the traditional charts. But the segments are filled with text alone (apart from a lone illustration of some glasses), in clean, hand-painted capitals. And rather than mapping behavior, as the traditional charts did, they map memories—from "Things I'm almost sure I know," to "Things I don't know how I know." The phrenology map has become a political comment on the former US Secretary of State for Defense Donald Rumsfeld's 2002 speech, discussing "known knowns" and "known unknowns."

Another updated and subverted version of the phrenology map was created by artist and book illustrator Oliver Jeffers. For the thirtieth anniversary of *Star Wars*, Oliver was asked to customize a sculptured bust of Darth Vader. His helmet is divided into hand-drawn segments and filled with character traits such as "tyranny and oppression" and "Han Solo bulls**t detection faculties."

I based my phrenology map on the first 19th-century prints of the discipline. The originals are black and white, covered in scrawled writing and tiny illustrations squeezed into the drawn segments of a head in profile. As in most mapmaking, the cartographer acts as editor, and it's fascinating to see what was considered an important personality trait worthy of inclusion, and what was left out, either because it was considered too superficial or just not yet recognized and understood. For example, traits like extraversion, openess, or thrill-seeking do not appear. In my version, I have modernized the vocabulary and symbolic illustrations. I have added some color, too, but more or less kept to the conventions and format of the originals.

– OVER TO YOU –

First, decide on the character and personality traits you want to add to each empty segment in your phrenology map. Can you add a familiar icon to symbolize each of your chosen traits? A heart can symbolize love, for example, or a nuclear bomb an explosive temper.

Think about where each trait is placed on the head. Should the area for good listening be placed near the ear, for example? Should the characteristic for deep spirituality and intuition be placed near the location of the "Third Eye"?

Consider subverting the map format. You could, like Jeffrey Fisher, theme your map and chart a conversation or an idea by breaking the subject into subtopics that fill each segment.

Or, like Oliver Jeffers, you could psychoanalyze a fictional character and create a tongue-in-cheek, "warts and all" map of their personality.

Think about what typeface you use. I enjoyed using a decorative serif typeface on my chart because it was reflective of traditional 19th-century maps. However, in your own map you could use a sans serif typeface for a contemporary, easy-to-read effect.

You could also change the size, color, or style of the typeface in relation to the personality trait. For example, use fierce red uppercase letters to label anger, or tiny cursive lowercase letters to suggest introversion.

Using the map on the opposite page as a reference, trace or sketch your own basic template of a head in profile, then ink in your original design.

PALMISTRY MAPS

"Cross my palm with silver and I'll tell you your fortune."
Palmistry is the ancient art of reading personality and
destiny from the lines and mounds on a person's hand.
Through the centuries, mystics have made maps to
explain how to understand the fate written on a person's
palm. Whether it fits with your personal beliefs or not,
it is an unusual, arcane approach to mapmaking.

For centuries and in many cultures, there have appeared
palm-reading maps covered in occult symbols and mysterious text.
The roots of palmistry can be traced back to Hindu astrology, but
Chinese and Romany fortune tellers also make claims. Western
palmistry focuses on the major lines of life, heart, and head, and on
minor lines such as health and fortune, which reveal something of
the person's past, present, and future. The maps also show the mounds
of flesh on the hand. Associated with the sun, moon, Mars, Mercury,
Jupiter, Venus, and Saturn, they have their own traditional astrological
symbols and tell us about our emotional and physical makeup.

SAYING IT IN PICTURES

French artist Eugène Lacoste's illustration for Adolphe Desbarrolles's 1859 book *Les Mystéres de la Main: Révélations Complètes* (Mysteries of the Hand: Complete Revelations) shows a traditional palmistry map in symbols alone. For example, the mound of Venus is shown with a loving couple, just below the thumb, and the angry plains of Mars are covered with depictions of a hectic battle.

MODERN PALMISTRY

Keri Smith is a contemporary Canadian conceptual artist and her *Touch Map* suggests a way to subvert the look of traditional palmistry maps. Instead of giving a key to fate, it maps in text the story of what the hand has touched— water, mittens, drool, a dog, lips, a phone. Perhaps indirectly it still says something about destiny: what the hand has touched and what it will touch in the future.

TRADITIONAL PALMISTRY SYMBOLS

| Venus | Mars | Jupiter | Saturn | Apollo | Mercury |

My own work (overleaf) was inspired by traditional palmistry maps, but I chose to bring it up to date by using a scanner to take a picture of my own hand and mapping out the lines, mounds, and symbols in ink.

— OVER TO YOU —

Research typical palmistry symbols and
lines, or use my map for reference. You
could use mainly text and a few symbols,
as I have done. Make the titles of the main
lines and planetary mounds stand out by
using bolder lines for these.

For a contemporary feel, use a variety
of sans serif lettering. It's a useful
style to incorporate if there's a lot
of information that needs to be
easily read in a small space.

You could avoid text and make your
map using just images, as Lacoste did.
You could, for example, show the "mound
of Venus" as a heart and illustrate a
mini brain to indicate "logic."

You may wish to subvert the traditional
palmistry map, as Keri Smith did, by
including in your text what the palm
has touched in the past, and also
what it might touch in the future.

MAPPING THE BODY

The interior of the human body has long been a fascination to many civilizations, and anatomy has been mapped throughout history. Some of these maps have been more anatomically accurate than others, but even the inaccurate ones provide inspiration for beautiful and unique works of art, so don't worry if your illustration skills aren't up to medical textbook standards.

As far back as the ancient Egyptians and Greeks, descriptions of bodily processes have relied heavily on the opportunity and ability to dissect humans. Drawings became an important way to carefully observe, understand, and replicate what was seen, in order to share the knowledge with others. Italy at the turn of the 15th century saw the most famous of anatomists, Leonardo da Vinci, begin to study the hidden world of human organs. By the beginning of the 16th century, as his public standing as a successful artist grew, he enjoyed increased access to corpses—often executed criminals—that he was able to dissect and map. Between 1510 and 1511, da Vinci made more than 240 highly detailed drawings, all notated in his crawling right-to-left "mirror script," depicting the human skeleton, muscles, sinews, veins, sex organs, and heart. His research became known as the "Anatomical Manuscript A," but was never published. Da Vinci's drawings are so beautiful and detailed that they are still studied today.

KEEPING IT SIMPLE

At the same time as Leonardo was creating his beautifully detailed anatomical maps, artists in England were offering some less sophisticated diagrams of medical knowledge. Several maps of the human body depicting a troubling figure known as the "Wound Man" appeared in manuscripts and printed books at this time. Alongside some explanations of where bodies are prone to injuries of a particularly 16th-century nature (such as penetration by sword and blows to the head), they also depict rough outlines of the internal organs. The illustrations are basic but colorful and show all they need to in a simplified way—demonstrating that creative vision can be just as interesting as medical accuracy. This was the approach I took with my *Totally Inaccurate Map of the Human Body* (overleaf).

IMAGINARY INTERIORS

Sharing knowledge about the body can also be approached more imaginatively, creating interior fantasy worlds to depict bodily processes. Utagawa Kunisada of Edo-period Japan was one of the 19th century's most prolific and successful designers of *ukiyo-e* (pictures of the floating world) woodblock prints. His *Dietary Life Rules* (also titled the *Mirror of the Physiology of Drinking and Eating*) shows a man sitting in front of a meal of fish and drinking sake. Utagawa maps the man's interior organs as if they are located in a large kitchen full of tiny men beavering away climbing ladders or firing cauldrons. Although the illustration is a very long way from scientific accuracy, it explains the digestive process in an accessible way to the common, unlearned population who bought the prints.

— OVER TO YOU —

Use a template of the human body from the back of this book to create your own map of the body's interior.

For a scientific map, do some research and indulge your curiosity finding out exactly how a body works. (It should no longer be necessary to obtain a cadaver to do this!)

For a map based more in fantasy, you could create an imaginary world of small people and machines, including cogs and levers, air bags and weights, working to make the body function.

Think about how lettering and drawing can be combined to depict this (generally) unseen place. You could use more compact lettering to label organs with small surface areas, and curve the words slightly around each organ to give it a more human, physical, 3-D feel.

Alternatively, you could avoid annotating the organs themselves and make a truly scientific-looking map by using indicating lines to label them.

A Totally Inaccurate Map of the Human Body

Brain

Lung

Lung

Heart

Spleen

Liver

Stomach

Kidney

Large Intestine

Small Intestine

Bladder

Kidney

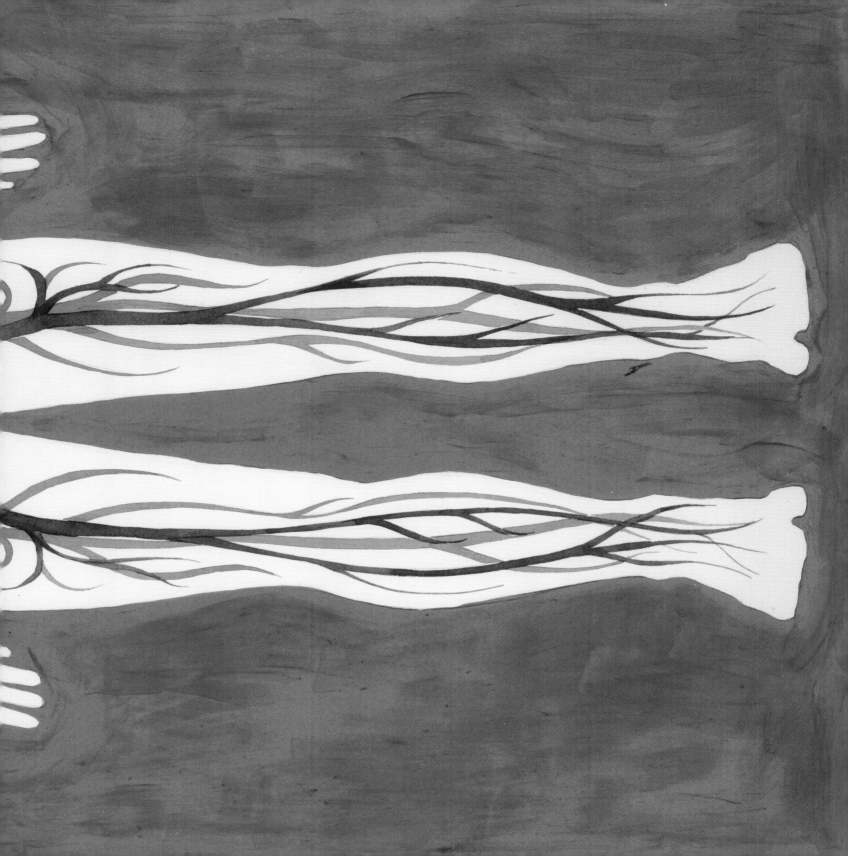

MIND MAPS

Mind-mapping has been around since the 3rd century (even Isaac Newton had a go) but it was first given its name by Tony Buzan in a 1974 episode of his TV show, *Use Your Head*. It's a visual way to collect and represent information using colors, symbols, different typefaces, and connecting lines to help you memorize and understand complex ideas. It's brilliant for problem-solving and brainstorming, too.

The main technique of mind-mapping is to divide a complex subject into its component elements, which in turn can then be divided into further, smaller parts. The gradation of increasingly minor or specific subtopics creates a clear hierarchy of the importance of ideas. Tony's maps are concise and devised to maximize understanding. Each element is interconnected with the one before and after it by curved lines. Apparently the brain is bored by anything straight! Similarly, as a further aid to gain ultimate intellectual power, he advises placing the main topic in the center of the page with subtopics radiating outward. Each element is represented with a different color, typeface, or image—whichever makes the idea most memorable. Tony suggests that by ordering and presenting a concept in this way, the brain works at its greatest efficiency, stimulated by word, image, number, color, and spatial awareness.

CREATIVE EXPRESSIONS

Not all mind maps need to be so technical. Elsa Mora is a Cuban artist now living in Los Angeles. Better known for her amazing cut-paper artwork, she has also worked as a painter. Her mind-mapping piece, *The Park as a Micro Universe*, uses text, color, and images in a more illustrative way, to dissect what you may find in a park if you pay attention. Topics are divided according to subject matter by mustard-yellow ribbonlike arrows and then divided into subtopics, which are bursting out as further arrows. Under the "human" topic come the subtopics of "pregnant women," "old couples holding hands," and the ubiquitous "man talking to himself." Under the "animals" topic come the subtopics of "ants," "ladybugs," and "dogs wearing coats." Each subtopic is illustrated with an image and handwritten text, creating a mind map that has character but is also very easy to understand.

My own mind map (overleaf) takes mapping as its main subject. I have divided this into subtopics, some of which you may recognize from some of the chapters in this book.

Each topic has its own color and distinct hand-drawn lettering style. For the subtopics I kept the lettering the same but used a lighter shade of the same color to distinguish them from the main topics.

Where possible I included images that illustrated a particular subtopic to act as additional memory aids.

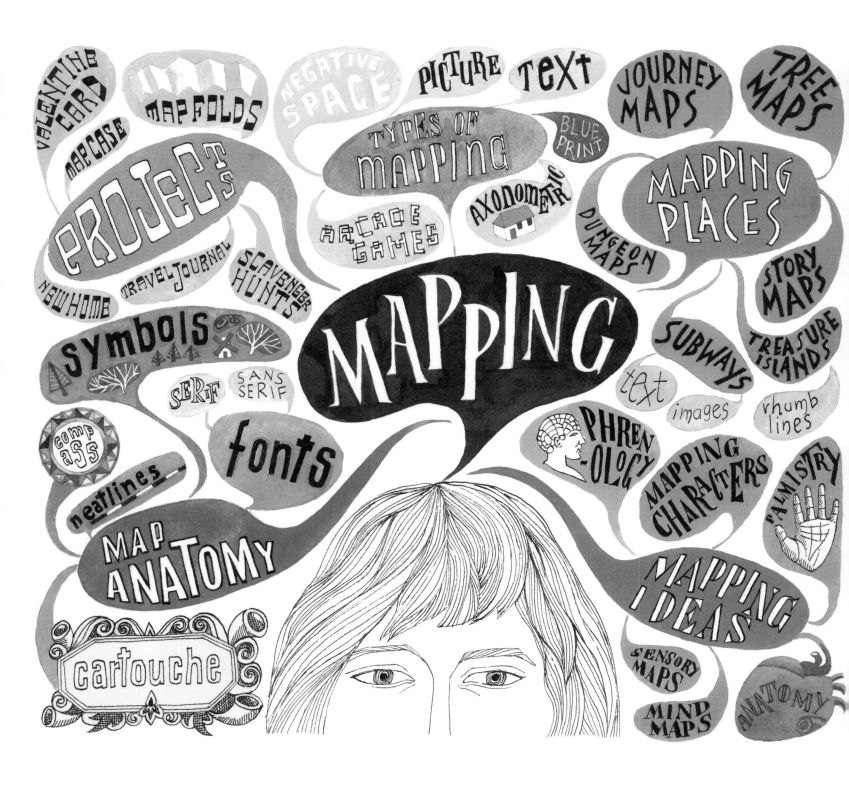

– OVER TO YOU –

Focus on how your map will clearly reflect the variety and development of your different thoughts and ideas. Your main topic needs to be written clearly in the center of the page.

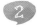

If you need to, break down the subtopics into further, smaller subtopics. Think about how you could further distinguish these to help make the map really clear and easy to read.

Split the main topic into as many subtopics as you need. These can be symbolized with different colors, typefaces, or lettering style and images. Each subtopic should be connected to the central main topic.

Perhaps there are links between the subtopics, too—how could you indicate these? Consider using clear pictures or symbols for appropriate topics.

You can add extra design features that could be simply decorative or help illustrate your thoughts. For example, I added a small drawing of a neatline to help readers understand what these are. I also included a portrait as a centerpiece to give the impression of thoughts floating out of someone's mind.

MAPPING PEOPLE

Mapping people has historically been the preoccupation of state officials, documenting populations to control, plan, and develop— sometimes for distinctly unsavory reasons. In these maps, geographic and urban features become secondary and it is the people, their demographics, and population numbers that become the focus.

A beautiful but cold map of New York City, created in 1894 in black and white, shows the metropolis's distribution of "Principal Nationalities." Each immigrant nationality is assigned a pattern, ranging from simple vertical stripes to cross-hatching to flat black. Each district is filled with blocks of pattern in proportion to the size of the nationalities living there. The overall effect is of a crazy patchwork quilt of monochrome abstraction—almost pop art–like in its aesthetic quality. The Germans and the Irish, the "Natives," and the "Bohemians" are all documented, but there is no sense of the lives and communities of those people at all.

In contrast, the colorful contemporary map of Manhattan by illustrator Hyesu Lee is filled with bright images of faces. Most standard geographical features have been removed; there are just handwritten subway routes and place names on the outskirts of the main image. Faces of people create the body of the map and it is they that feel most important, suggesting teeming crowds and a joyful multitude of ethnicities.

MAPPING LIVES

Time-travel across the oceans to Hong Kong (China) between the end of the Second World War and the early 1990s, and you might have come across the unruly walled city of Kowloon. With incredible towers of passageways and cramped tenements, this was once the most densely populated place on Earth, and it was riddled with crime and prostitution. Before the bulldozers arrived in 1993, a group of Japanese researchers, led by architect Hiroaki Kani, mapped the entire city. The resulting book is filled with cross-sectional maps of people, homes, and businesses. Every feature is documented in minuscule detail, from mah-jong clubs to strip joints, from saucepans hanging on kitchen walls to boxer shorts hanging out to dry. It is incredibly intricate and gives a fascinating insight into a lost city.

THE HEART OF A CITY

Now to the creation of my own map. Imagine a long weekend in Stockholm, Sweden. I'm sitting in a café with the spring sunshine slowly approaching my eyeline, halfway through a coffee, with lingonberry pancakes on the side. There's a sketchbook in front of me and I'm documenting whoever wanders past as I people-watch. I'm catching the quirks of Swedish fashion, the punks and the pensioners, the hipsters and the occasional drag queen. The finished map you see is the outcome of that afternoon of sketching, focusing more on the people who live in the area than on any geographic or architectural feature, their faces filling all the available negative space. It's the people who are the true heart of any city.

BIRGER
JARLSGATAN

BRUNNSGATAN

KUNGSGATAN

OXTORGSGATAN

LÄSTMAKARGATAN

KUNGSTRÄDÅRDSGATAN

REGERINGSGATAN

JACOBSBERGSGATAN

MALMSKILLNADSG.

- OVER TO YOU -

 1

Visit a location you would like to map, preferably a quite busy place where you will encounter a variety of people. Spend time observing who you see in the area and make some quick sketches of the aspects of people that catch your eye—an interesting hat, a large beard, or a pair of outlandish sunglasses.

 2

Make a note in your sketchbook of the exact location of where you see each person, so when you refer back to your notes later you can plot each person in the correct place on your map.

 3

Create a map of the streets in your chosen area, in the style of a negative-space map (see pages 52–55). Then plot all your local characters into the negative spaces between the roads, in the area that corresponds with where you saw them.

 4

You could simply draw the faces of each character, as I have done in my map. Start by filling each area with simple circles and then build each one up into an individual character using your sketches as reference.

 5

When adding detail to your portraits, focus on the distinctive details that make each character unique—for example their fashion choice, hair color, or face shape.

 6

If you prefer, or if you only have a few sketches to work from, you could include an entire person as opposed to a simple head portrait for each character.

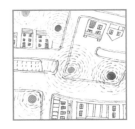

SENSORY MAPS

We use more than just our visual sense to locate ourselves—hearing, touch, and smell all play a part. A bakery, a petrol station, a bar, a public restroom, a laundromat, for instance—these all have particular smells. It is possible to create a truly unconventional map of a place, using our other essential senses.

Contemporary artist Kate McLean uses the sense of smell in her work as an artist-cartographer. She walks around cities or neighborhoods documenting what she encounters. Many of her maps feature smells indicated by swirling pale-colored dots—intense in some places, merging like clouds in others. Although the finished documents are not always hand-drawn, the mapping itself is a performative process and the location has been physically experienced in person.

For her map of Singapore, McLean gathered 200 walkers together to collaboratively collect smell data. The finished map gives a strong physical and sensory evocation of the place—a "nose-first" view of the city. A simple key is used, and a dot of each color represents a different smell. Scents of jasmine, shisha, and saltwater hover; "smoky, hot" notes are interrupted by clustered mustard dots—the reek of the durian fruit (which smells so bad, it's banned from public spaces). There are also "curious scents" that could only be understood if you'd been there: "dinosaur," "a hard life," and "broccoli/deep dark secrets." It gives an effective sensory picture of a place experienced by individuals and collectively as a group—something a conventional map could never do.

Kate's smell-map of Milan, *From Preconception to Perception*, looks very different. The city was mapped with handmade 3-D paper sculptures, featuring iconic architecture and important buildings drawn in scrawly black pen. The smells found around each area were re-created (hand-brewed by maker and scent-designer Olivia Alice Clemence) and placed as diffusers inside the corresponding models. The smells recorded and re-created were diverse and also subjective. Gin and tonic wafted from the tiny nightclub; fish food from the miniature Milan Aquarium; and chocolate and strawberries from the convent, Santa Maria delle Grazie, home of Leonardo da Vinci's *Last Supper*.

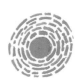

For my own sensory map of the seaside town of Brighton on the south coast of England, I used Kate's technique of symbolizing smells by color.

The intensity of fragrance is shown by the colored contour lines, which are drawn closer together for a stronger smell or wider apart for just the hint of a smell (similar to how contour lines are used to show elevations in topographic maps).

As different scents merge with each other, the corresponding contours overlap.

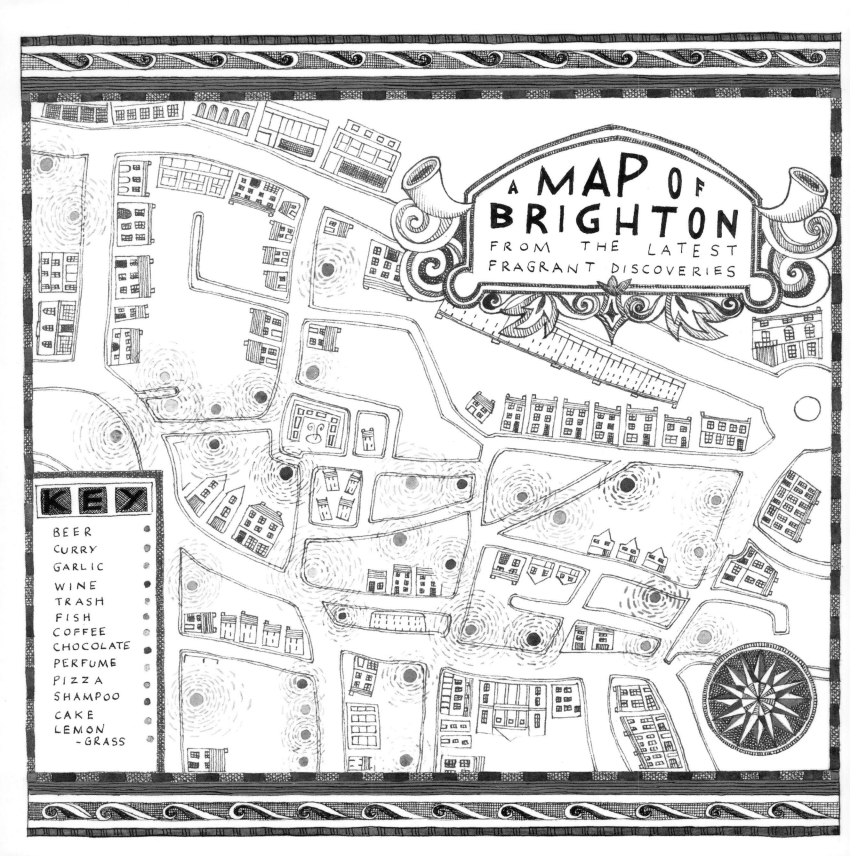

- OVER TO YOU -

Using an existing map as a reference, plan a basic map of the area you want to map—including any streets and pathways, back roads, and parks.

Get out and walk the area you have mapped. Take your map with you and make a note of the strong smells and mark where they occur on the map.

Think about how you will visually represent each smell. What symbols will you use to distinguish one smell from another?

How will you show when the smell is very strong and near its source? How does it look when it disperses and what happens when it merges with other smells? You could use contour lines, dots, dashes, symbols—even lettering that becomes more condensed closer to the source of the smell.

You may wish to add some additional features and landmarks to your map, as I did, but remember to keep these pared down so they do not distract from your smell symbols.

Remember to make a key that shows the symbol for each smell and what it means. Also think about where you might add a cartouche and a compass rose to your map.

MAPPING MOVIES AND FICTION

Some of the best hand-drawn maps I've seen have been of fictional places such as Tove Jansson's Moominvalley or J. R. R. Tolkien's Middle-earth. Created to show an overview of the landscapes of, and relationships between, fictional places, they are often created by the authors themselves and give the reader a true insight into their imagined worlds. However, you don't have to be an author yourself to create your own inventive fiction maps.

Sometimes maps are simply inspired by fiction and not initially described in great detail as part of the plot. Gotham City, of DC Comics' *Batman* series, was only ever a vague, dark skyline at the beginning and didn't even have a name until 1940. In 1999, however, illustrator Eliot R. Brown was asked to create a map of it for the "No Man's Land" story. His city shows many of the locations where action takes place, but also the mass of roads, subway systems, seamy docks, and glitzy entertainment districts. Incidentally, the map has now become the standard representation of Gotham in all media.

USE YOUR IMAGINATION

A Partial Map of Your TARDIS (Subject to Change) is an imaginative homage to the BBC's long-running TV show *Doctor Who*. It is a mix of fan art and fan fiction, created and shared online by the Internet user "alibi_factory," and consists of a collection of maps, executed in a variety of styles, charting areas of the Time Lords' vehicle (which is famously larger on the inside than it looks from outside). It includes straightforward maps like that of the console room—"Where things happen"—to complex maps of the shipyard—which seems to be fashioned around a paper airplane and stores escape pods and jet-packs. With fictional maps, the only limits are the artist's imagination.

PLOTTING FILMS

The webcomic *XKCD* features several charts mapping character interactions within movies such as *Jurassic Park* and *12 Angry Men*. All hand-drawn, every character has its own colored line, with handwritten notes pinpointing each interaction with another character (where the line crosses with another). As the movie progresses along its horizontal axis, you can follow each line and see how a character moves apart from or comes together with another character. The maps look like long skeins of tangled wool but somehow are still clear to read.

My own map documents the plot of the classic 1939 movie *The Wizard of Oz*. Each plot point is shown in circles, which are color-coded to symbolize various locations.

The movement of the characters and some of the action are shown using small illustrations and arrows.

I liked the cyclical nature of the story, so I used circles as a recurring motif.

THE JOURNEY OF DOROTHY GALE FROM KANSAS TO OZ AND BACK AGAIN

DOROTHY GALE LIVES WITH AUNT EM, UNCLE HENRY & TOTO THE DOG ON A FARM IN KANSAS.

TOTO BITES MISS GULCH.

MISS GULCH THREATENS TO PUT TOTO DOWN.

A CYCLONE TAKES DOROTHY, TOTO & THE FARM TO OZ.

THE FARM LANDS IN MUNCHKINLAND. RIGHT ON TOP OF THE WICKED WITCH OF THE EAST. GLINDA, GOOD WITCH OF THE NORTH, TELLS DOROTHY TO ASK THE WIZARD OF OZ HOW TO GET HOME AND GIVES HER THE WITCH OF THE EAST'S RUBY SLIPPERS!

WE'RE NOT IN KANSAS ANYMORE!

FOLLOW THE YELLOW BRICK ROAD...

DOROTHY MEETS A TALKING SCARECROW WHO JOINS HER QUEST.

I ONLY WANT A BRAIN.

SHE MEETS A COWARDLY LION IN A FOREST WHO JOINS HER QUEST.

TREES THROW APPLES AT THEM.

SCARECROW ALMOST CATCHES ON FIRE!

FIELDS OF ENCHANTED POPPIES SEND THEM TO SLEEP.

GLINDA MAKES IT SNOW AND SAVES THEM.

I ONLY WANT A HEART

SHE MEETS A RUSTY TIN MAN IN THE WOODS WHO JOINS HER QUEST.

I ONLY WANT COURAGE.

THEY REACH THE EMERALD CITY AND SPEAK TO THE GREAT & POWERFUL WIZARD OF OZ. HE AGREES TO HELP THEM IF THEY BRING HIM THE BROOMSTICK OF THE WICKED WITCH OF THE WEST.

THE FOUR FRIENDS SEARCH FOR THE WITCH.

THE TINMAN, SCARECROW & LION ESCAPE TO THE CASTLE.

I'LL GET YOU, MY PRETTY!

DOROTHY & TOTO ARE CAPTURED BY THE WICKED WITCH OF THE WEST. THE OTHERS FIND THEM.

I'M MELTING!!!

THE WITCH SETS THE SCARECROW ON FIRE. THE TIN MAN THROWS A BUCKET OF WATER OVER HIM & THE WITCH GETS WET. SHE DISSOLVES!

THEY RETURN TO THE CITY WITH THE BROOM!

THE WIZARD IS REVEALED TO BE A FRAUD AS TOTO PULLS BACK THE CURTAIN!

THE LION, TINMAN & SCARECROW BECOME RULERS OF OZ.

THERE'S NO PLACE LIKE HOME

SHE MEETS PROFESSOR MARVEL WHO PERSUADES HER TO RETURN HOME.

THE WIZARD FLIES BACK TO KANSAS.

WITH GLINDA'S HELP THE RUBY SLIPPERS TRANSPORT DOROTHY HOME!

DOROTHY RUNS AWAY WITH TOTO TO SAVE HIS LIFE.

— OVER TO YOU —

Make notes on the main points of action in the plot. Which characters are present and how does the action move forward? Where does the action take place?

How will you represent the information and how the action develops? You may want to make some preliminary sketches and experiment with how to bring these together in relation to one another.

3

Make notes on the places shown or described and the relationships and distances between one place and another. In your map you could place the book's main location in the center of your page, then work outward and add further locations in relation to this central one.

If there are any particular geographic features mentioned, such as mountains or forests, add symbols to represent these. Don't forget to add a cartouche and a compass rose. Turn to pages 12–15 and 24–27 for guidance on how to create these.

One interesting idea to try is to plot the characters' interactions. Use a piece of paper, lengthwise. The left-hand edge is the start of the plot; the far right is the end. Make a list of the principal personalities at the start, giving them each a color. As the plot unfolds, draw a line for each character and bring them together at each plot point where they meet.

MAPPING FAMILIES: GENEALOGY CHARTS

Ever been fascinated by the complex relationships and movements of your ancestors? Of the numerous ways to map a family, the family tree is the most well-known. Family trees usually present the oldest generations at the top, with the following generations branching off below. Naturally, it's broader at the top with more branches of older generations and narrower at the bottom with fewer. This shape is where the "tree" term comes from.

The simplicity of the family-tree format means that it lends itself to mapping interconnectedness in many forms. A beautiful infographic diagram by British illustrator Joe Stone shows the relationships between characters from the Marvel Universe: the X-Men, the Avengers, and the Fantastic Four. Each character is symbolized by an icon, and the nature of the character's relationship with others is shown using a colored line: blue for married, red for offspring, and so on. The intricacies are complicated, but as Joe says, if you are confused, read more comics.

MAPPING THE FAMILY DIASPORA

Another way to chart family history is not by mapping relationships but by mapping their movements over time. Do you know where your family comes from? Did family members immigrate from another country at some point? Even in my own recent family history, there are connections with North America, Australia, Peru, Hungary, and Nigeria, but perhaps your family has a story of immigration that goes back centuries. In this kind of map, each family member can be pinpointed with their own color on the globe and from there corresponding arrows track that person's movements across the world, ending at their most recent home destination. The map becomes a crisscross of colored lines not only reflecting family history but world history, too.

My own map is inspired by 19th-century family record books, which allowed owners to chart family births, deaths, and marriages. Most examples have a decorative border full of flowers and frames, and often locket-shaped spaces for photographs or pictures. A family-tree map like this can not only become a beautiful heirloom but would also make a very personal gift to a family member.

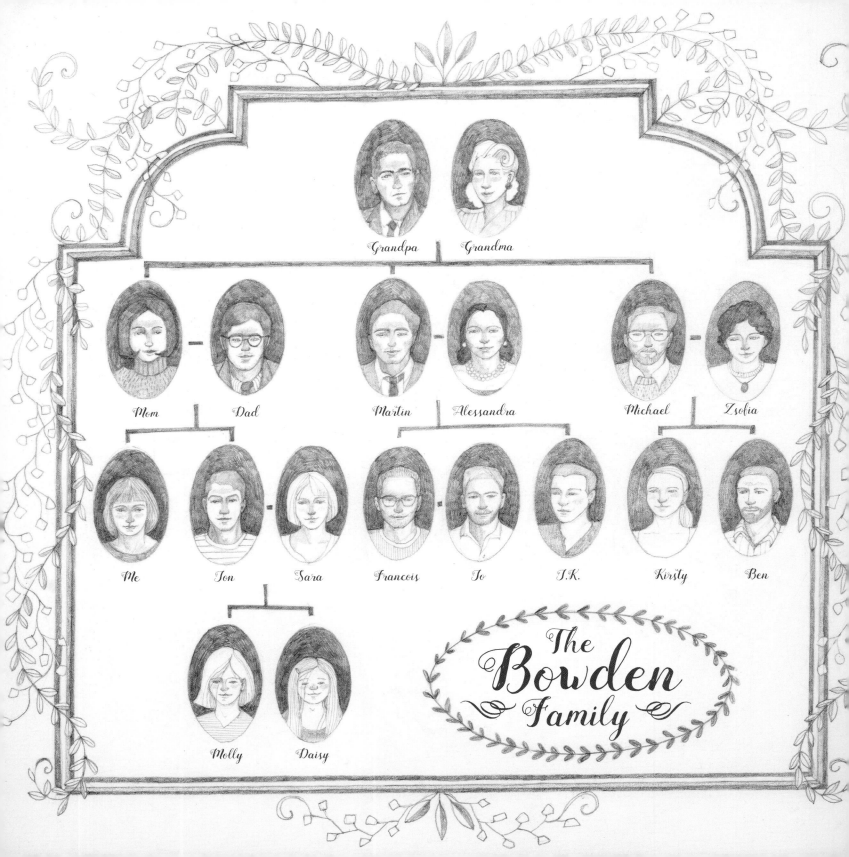

Grandpa Grandma

Mom Dad Martin Alessandra Michael Zsofia

Me Jon Sara Francois Jo J.K. Kirsty Ben

Molly Daisy

The Bowden Family

- OVER TO YOU -

1

Start by planning a simple family tree, going as far back in your family history as you know. The earliest ancestors should appear at the top, continuing line by line down the page through the generations, finishing with the most recent family members at the bottom.

2

You could map just one side of your family (your maternal ancestry, for example) or broaden your map to include both maternal and paternal ancestors.

3

Choose a style of lettering that complements your overall theme. I opted for a serif script to give my map a traditional feel.

4

For each family member you could draw a decorative oval shape above the name and add a portrait. You could use photographs as a reference, or just draw a basic face and symbolize each person with their most distinctive characteristics.

5

To finish your map, you might find a good space for a cartouche that you could border with flowers and foliage like the family record pages. You could echo this design by giving the map itself a border.

ANTOINE CORBINEAU

Antoine Corbineau is a French multidisciplinary
creative, currently living and working in Nantes.

His fine art and illustration work incorporates a range of media, techniques, and styles,
including busy patchworks of texture, imagery, and creative typography. His maps can
capture a simple key message but are also richly illustrated and fun. This style and
approach has made him popular with major design and advertising agencies worldwide.
You can find out more about his work online via his website: www.antoinecorbineau.com.

Q: What is it that you enjoy about creating hand-drawn maps?

I enjoy the freedom it allows me, the possibility to take a step back from reality
while also engaging with the spirit of a place. Hand-drawn maps express the life
of places as well as conveying information about them.

Q: Can you tell us about your map of Milan, shown here?

The map of Milan Porta Venezia is one of my favorites. With this map I wanted to distance
myself from a traditional cartographic style and instead favored a minimalist, more abstract
visualization of the city, using a limited color palette and simple shapes.

Q: What tips would you give to people interested in creating their own hand-drawn maps?

I would advise them to think outside the box, to push toward innovative new ways of
representing a place. Focus on what life there is on there, and don't go retro: experiment!

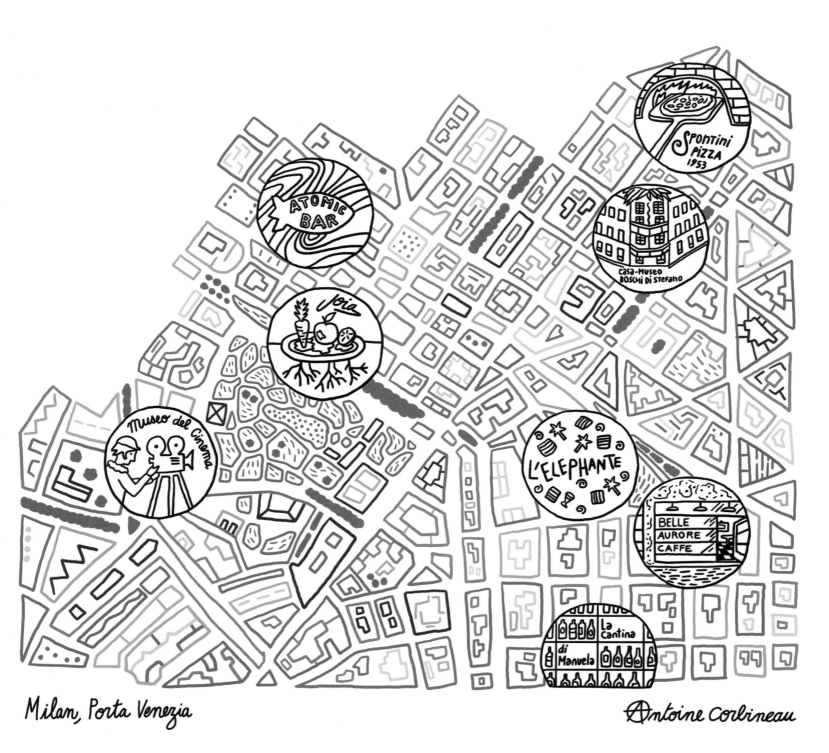

Milan, Porta Venezia

Antoine Corbineau

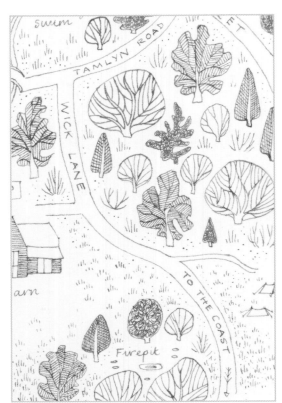

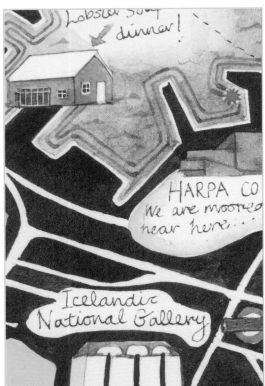

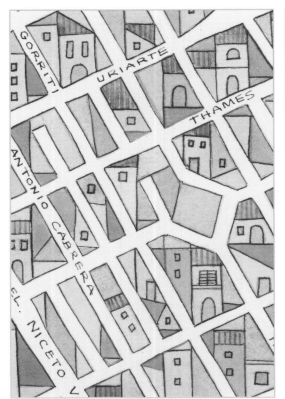

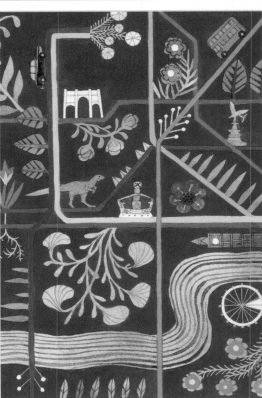

PROJECTS

WEDDING MAPS

Maps are often included as part of an invitation to an event, such as a party or ceremony of some kind. Weddings are no exception.

I have seen many ways to use maps as part of weddings. For a couple who have traveled, a travel-themed wedding is perfect. Invitations can be made from vintage maps and sent in airmail-inspired envelopes. For city-based couples, I've seen both invitations and place settings themed around iconic transit maps like the New York subway system or London Underground. But more often than not, the map simply comes as an addition to the invitation, serving a functional purpose. It usually gives directions to the wedding venue and reception and there's no reason it shouldn't be as beautiful as the invitation itself. A hand-drawn map can be totally personalized to the couple—something a wedding should always be.

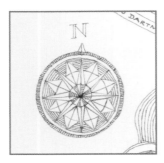

An ornate compass rose.

Nearby accommodation and landmarks.

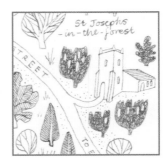

The wedding venue.

THINGS TO CONSIDER

Before you start drawing, decide on the size and format of your invitations. Printers have a standard set of sizes for paper and envelopes, so it's best to first know what these are and then base your design around these dimensions. Also, think about whether you would like to use a single color or many, as this, along with size, will affect printing prices and your overall wedding budget. It's probably a good idea to talk to a printer first and find out exactly how they need the map to be presented—as flat artwork, or already scanned and presented digitally.

Besides the obvious information about the venue, sometimes it's good to add extra details. In the case of my wedding map, I knew there was a mix of places to stay nearby, from camping to a local boutique hotel, and that there was an evening planned around a woodland fire and a morning dip at a river-swimming spot for the next day (hangovers permitting). This information was included so guests knew to bring warm clothes and swimsuits.

You could add illustrations as you would in a picture map (see pages 40–43). I used images of the church and reception venue in my map. Other features, such as the local river, woods, and a bridge were added to help people orient themselves. Because the location was fairly rural, and most people would be driving, I also included parking information.

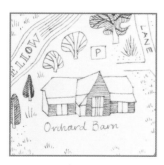

The reception venue, with parking.

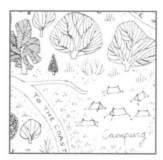

A local campsite, possible accomodation for guests.

A cartouche, commemorating the couple and the date.

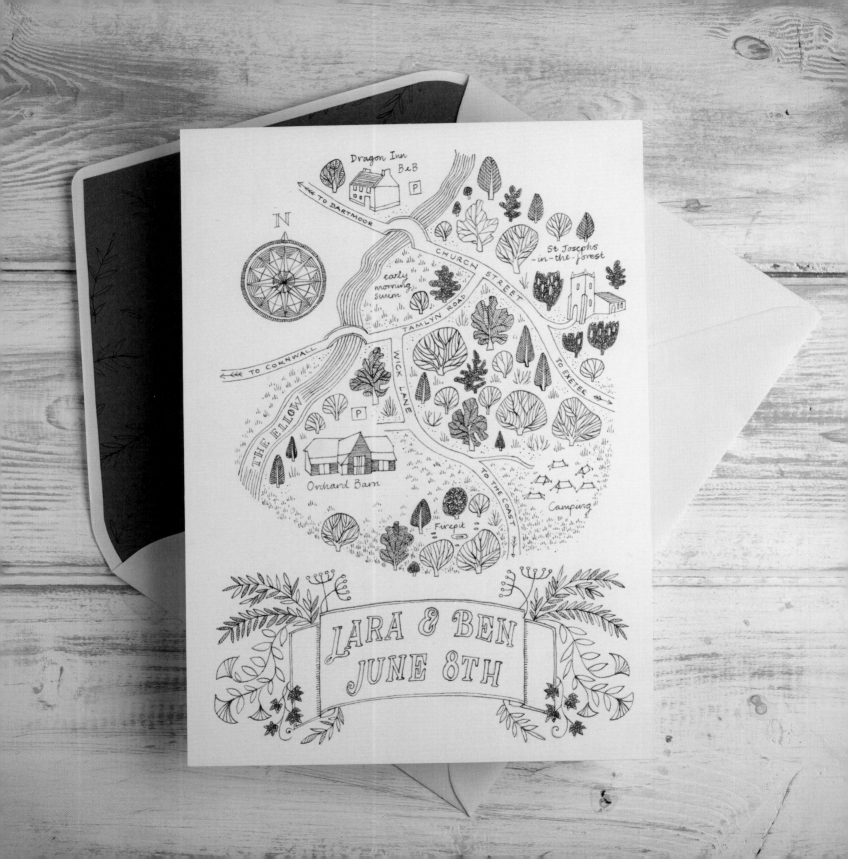

– OVER TO YOU –

Make a list of information you need your guests to know. This might include the addresses of the wedding venue, where the celebrations will be held afterward, places to stay—suiting different requirements—and the roads and major routes from all directions.

Using a traditional map or online reference, make a quick sketch of where the main features are in relation to each other. This landscape will need to be fitted to the dimensions of your invitation. Adapt the scale according to the distance between each landmark.

If you plan to use symbols or pictures in your map, go through your list of information and decide how you could illustrate these elements (for example either a letter *P* or a picture of a car could represent the parking area).

When decorating the map, think about how the colors you use can complement the overall scheme for the wedding. Using your own hand-lettering can add an authentic, personalized touch.

Once you have drawn your map, remember that elements from the wedding map can be used elsewhere—on place settings and envelopes, for example.

TRAVEL JOURNALS

Travel journals are personal accounts of a trip or adventure. Often they can be elaborated with pictures, collected ephemera, and maps. A few years ago, I sailed 1,300 miles (2,000 km) with a group of oceanographers across the North Atlantic from Iceland to Sweden, to track whales. While aboard our little boat, I mapped the voyage in stories and sketches, although the stormy weather didn't make it easy.

I traveled with several incredibly experienced sailors—people who had witnessed 160-foot (50-meter) waves in the Atlantic, navigated by the stars with Polynesian tribesmen, and free-dived (without oxygen tanks) with blue whales. It is from them that I learned something of traditional maritime charts and also the old ways of navigation, without the use of standard map symbols. I wanted to remember our conversations, so when I wasn't working on board, I made notes.

I've kept the journals I made, and I find that the maps in particular are really important to me. They pinpoint exactly where I was at a particular time and what I could see or hear at that moment. Recording this information has made my memories far richer. Heavily detailed with notes, filled with stories and hand-drawn images, my journal maps are a truly personal record of the voyage.

There's something very satisfying about sitting in a bar in the evening, mapping your day's adventure over a beer. Of course, it's your choice whether to keep the journal totally personal and private, but occasionally I've found working on it to be a great conversation starter and the beginning of some interesting evenings with strangers. And this, of course, leads to some more stories to add to my journal.

– OVER TO YOU –

Make sure your sketchbook is portable and durable—something with a hard cover to weather any battering as you travel, and small and light enough to not weigh you down.

Decide beforehand what equipment will be most useful and convenient for drawing on the go. My personal drawing equipment is a selection of pencils and pens. I usually add color when I'm back at my studio, but you may opt for traveling with a mini paint palette and a screw-top jar for water. Alternatively you might consider watercolor brush pens, or simply felt-tip pens or colored pencils.

Journals can be made anywhere, and could include a written diary entry, accounts of overheard conversations, or general impressions. It's easier to work like this when you are traveling or exploring on foot.

To give a more in-depth impression of your destination, consider adding more detail by using an existing map of some kind as a reference. You could use online resources, depending on how easy it is to access the Internet on your travels.

Add in some illustrations. Somehow these can feel more authentic than taking endless photographs that are rarely printed and barely looked at.

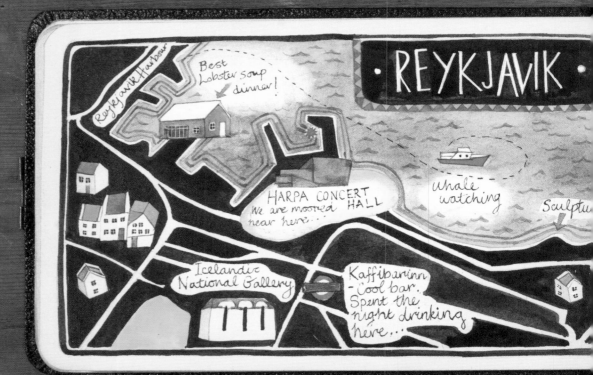

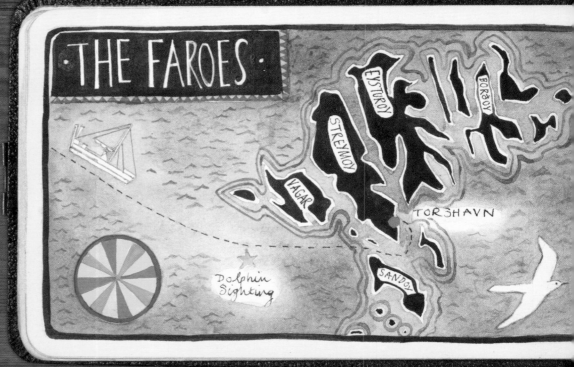

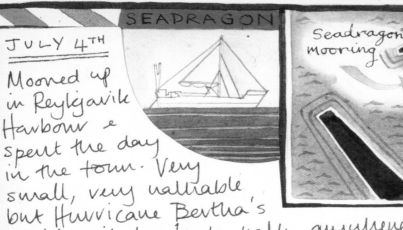

JULY 4TH

Moored up in Reykjavik Harbour & spent the day in the town. Very small, very walkable, but Hurricane Bertha's making it tough to walk anywhere really. Got dinner at Saegriffen at the marina. INCREDIBLE lobster soup... Spent the evening at Kaffibarinn — cool bar.

SEADRAGON

Seadragon mooring

HARPA

TORSHAVN

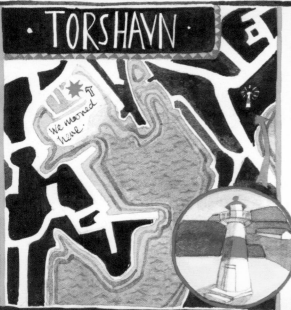

We moored here.

JULY 15TH

Made it to the Faroe Islands after fairly smooth crossing. Saw some dolphins but few whales. Moored in Torshavn harbour for a few nights to stock up and refuel. Got some fresh fish from the local market for a quick BBQ on the keyside. Fiver beer in a week... Lighthouse looks pretty. Will visit tomorrow.

VALENTINE'S DAY CARDS

Valentine's Day comes once a year, and love it or hate it,
Valentine's Day cards can be seen and bought everywhere.
But a hand-drawn card is something unique, and putting your time
into something personal can be seen as a highly romantic gesture.
Maps have been used to show the journey of love for
centuries, so why not use a map as the basis for a Valentine's card?

A beautiful example of a map exploring love was published in the mid-19th
century by D. W. Kellogg. Titled *A Map of the Open Country of a Woman's Heart*,
it shows a heart-shaped image as a landscape. Its creation is attributed to
"A Lady." This lady, however, seems fairly superficial, and her heart is mapped with
"The Sea of Wealth," "The River of Lasciviousness," and the "Region of Sentimentality,"
among other less than positively named places!

Johann Gottlob Immanuel Breitkopf's map, created in 1777 and titled
The Empire of Love, has a slightly more balanced view of love. Drawn as a traditional
map, it shows "Marriage Harbor," "Affection Farm," and the "Fountain of Joy" alongside
the "Flood of Tears," "Desert of Melancholy," and the "Hopeless Mountains."

The Heights of thinking about you every day...

The forests of baking cakes for you that always get burned.

THE ROAD TO YOU

The Lakes of lazy afternoons Laughing with you

the Oceans of starlit skinny dipping & fires on the beach.

The Plains of freshly brewed coffee in the morning.

The Mountains of late nights, loud singing, and too much red wine.

THE RIVER OF LOVE

A Map of My Heart

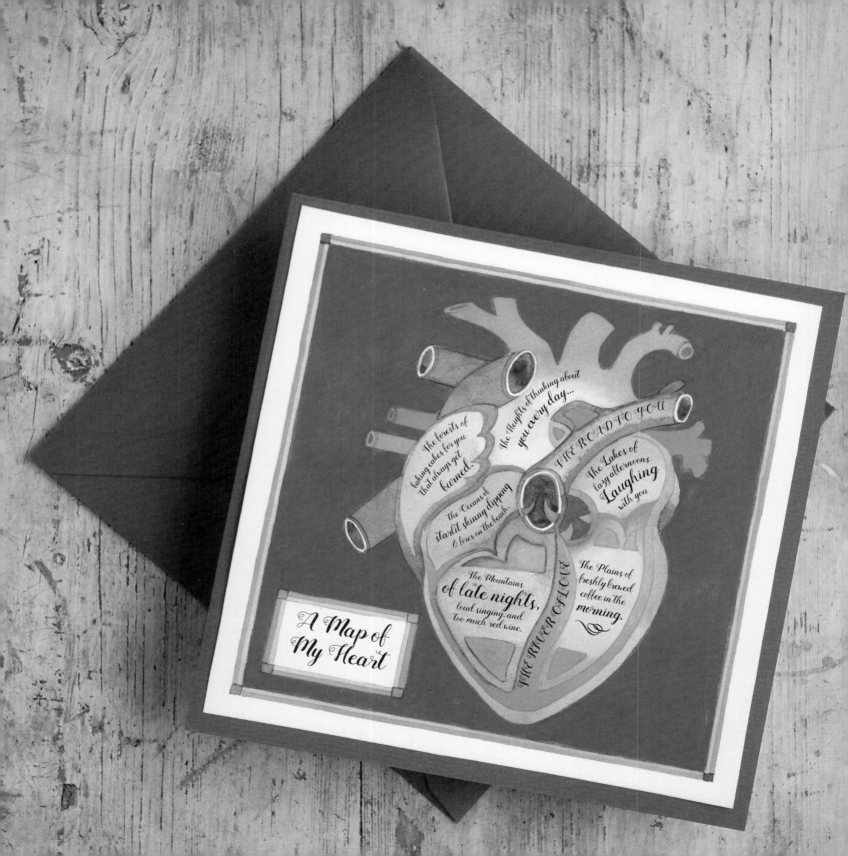

— OVER TO YOU —

Create a list of the things you want to express on your card, special details about the object of your affection, and consider how these could be best represented visually.

Consider how you will present your message and section off areas of your map accordingly. Be sure to leave enough space for any text you want to add. Alternatively, think about creating and incorporating symbols as features that represent the list you have made.

Plan the concept for you card. Will it (like mine) map the landscape of your own heart, of love itself, the figurative journey you've been on with your partner, or, if you prefer to do something simpler, literally the journeys you've made together?

Think about the different effects you can create with typefaces. I used a curly romantic script but, if you wish to give a cooler impression, you could go contemporary with a clean sans serif font.

Reds and pinks are, of course, the traditional colors associated with Valentine's Day, but this card should be a unique expression of your love, and the object of your affection, so do not necessarily feel swayed toward convention when choosing the color scheme of your card.

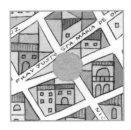

NEW ADDRESS CARDS

When you move home, you need to let friends know the location of your new place. It is customary to send out new address cards, and often these will include a useful map. Hand-draw your own, and something otherwise mundane can feel much more personal. If you treat it with some creativity, it can be beautiful, too.

I chose to make a map itself the main feature of my new address card and used a negative-space map as a base for the design. By keeping the road system a neutral white, I focused on the bright decorative elements in the negative areas, making for an eye-catching card.

Another style I considered for my card would have used as its base an annotated map (see pages 80–83). This design would have a simple skyline, based either on your town or a generic skyline of different-shaped rooftops and buildings. The skyline would be annotated with details of the location, and make use of contrasting typefaces. I would pinpoint the new address with a colorful icon and also state it clearly in words, as with this style of map the exact location will not strictly be navigable.

SIZING THINGS UP

If you plan on sending many cards (to friends, family, colleagues, etc.), there are numerous companies online that offer affordable rates for print runs of cards featuring a scanned version of your design. If you plan on sending only a few, you can of course make the cards individually yourself.

A card sent in the mail is more likely to be kept than an email sent to a person's inbox and then lost among their many other messages. If you opt to mail your cards, make sure your design is a standard dimension that will fit in an envelope. When drawing your map you might have to adjust the scale to ensure you can fit everything in. Check that there are no important details near the edges, because they might be difficult to see, or get cropped off by the printer (if you are using one).

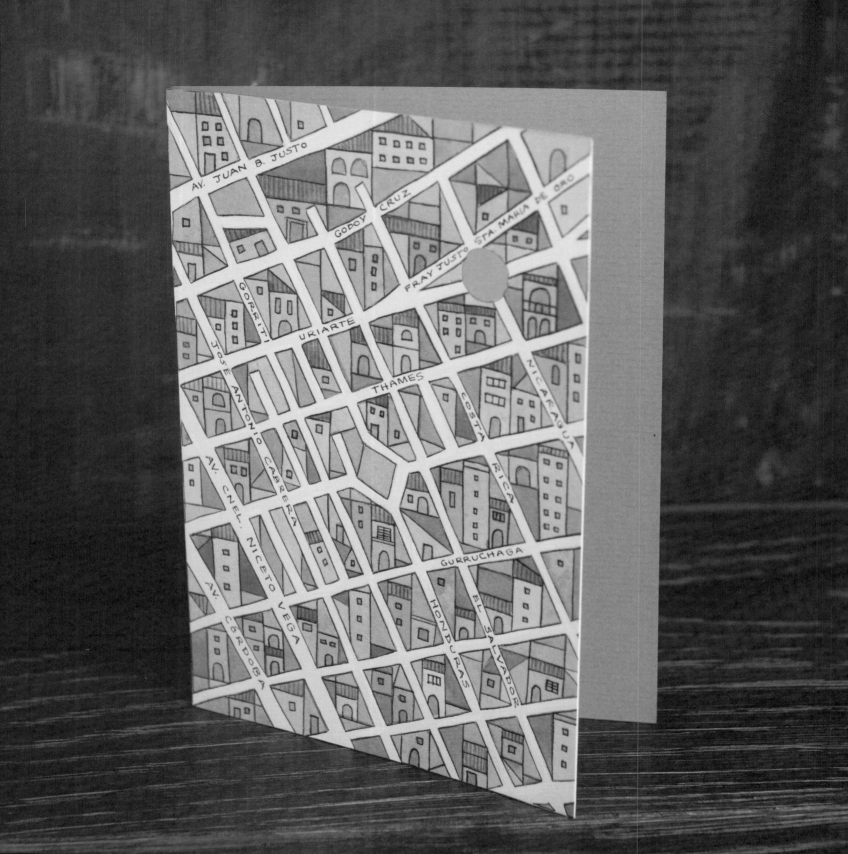

— OVER TO YOU —

To create something similar to my new address card, start by roughly sketching the area where you live and pinpointing your new home.

Carefully label all the major roads, and make sure the name of your own street is clearly readable. I chose to use simple hand-drawn lettering to contrast with the colorful detail elsewhere on the map.

On paper, mark out the correct dimensions to fit your chosen card size, and transfer your map drawing on to it, adjusting the scale if necessary to make sure all the important details fit. This could be done easily using a photocopier or image editing software. Alternatively, you could adjust this by hand.

I decided to paint my design in full color, but it could be just as effective to keep your design monochrome with the use of a simple ballpoint pen. Mark the location of your new home with an obvious symbol. I used a big yellow-orange circle, but style your own placemarker to suit your personality, or whatever impression you wish to make.

If you wish to create a negative-space map, as I did, keep your roads very plain and focus your design on the spaces in between. For a subtle and simple effect, you could personalize these areas by simply adding plain color. Alternatively, you could add details that reflect the character of your new area.

BUSINESS CARDS

In today's world, setting up a simple business is fairly easy, with plenty of tools available online and on social media that provide access to a worldwide market. However, there are often moments of personal connection when networking opportunities present themselves offline. For these occasions, every good entrepreneur needs a business card.

The address, phone number, email, and website or social media details should always be clear on a business card, and it should explain, either in writing or visually, what your business is about. A hand-drawn map on a business card can show clearly the location of your business, but it can also visually demonstrate or illustrate what you do. And most importantly, it's a physical object that can be made distinctive and memorable.

For my design, I used a transit map as the basic concept (see pages 68–71). Instead of using this in the obvious way—to give directions or show the business's location—I used it to talk about what the company does. Each station becomes a service feature and the train lines become a way to show the sometimes linear, sometimes looping business process.

The zigzag fold format is unusual, but gave me more space to work with in. The card is also more substantial and less likely to be thrown into a drawer and forgotten.

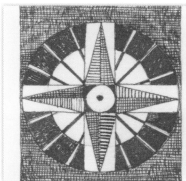

This is the business card, folded, from the front (left) and back (right).

When the card is folded out, the map design is revealed.

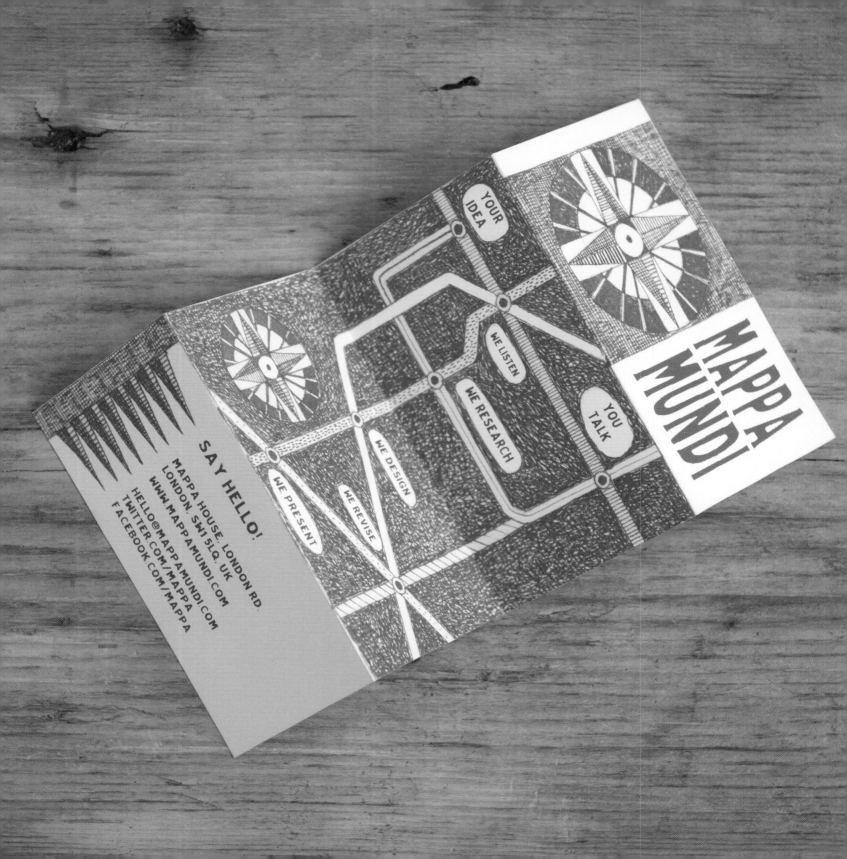

− OVER TO YOU −

1

To make a business card like mine, look online for companies that allow you to upload your own scanned designs that they will print for you. Or you could talk to a local printer. Each will require the design to be delivered to their own specifications. Business cards have fairly universal dimensions, which you need to take note of before you start designing.

2

Think about what your business does. Do you sell a range of products? Do you deliver a service? Is there a process your customers need to know about? Make a list of all the things you need to tell them. This will form the basis of your map.

3

Also, make a list of the other important details a business card needs. These could include your name, the business name, postal address if there is one, contact numbers, website and email, or social media addresses.

4

Make a rough plan of how you will fit the information into the chosen dimensions of your card. As it's only a small space, don't overcrowd it with too much information. Focus on the essential things. If using a similar format to mine, allocate a section for each specific piece of content, for example, your logo, social media username/handle and address details, and map.

5

Draw your map out in the space you've chosen. Perhaps use a familiar transit line as inspiration (see page 71). Most transit maps differentiate each line with color, but you could also use pattern, as I did. Each station should indicate what you sell or do, or the journey of a service process.

6

If, like me, you adopt a transit-map style in your design, add information about your business or any extra details you need to include as your station names.

MAP FOLDING

One of the less obvious joys of creating your own maps by hand is
discovering the numerous different ways to create folds in them.
While you may recognize the familiar fold of a standard road map—
and the frustration of trying to fold it back again—you might
not be aware that this particular style of map fold is only one of many.

The general purpose of adding folds to maps is to make them portable. Most road maps
have conventional horizontal and vertical folds, but others include diagonal folds.

The Miura map fold takes its name from the Japanese astrophysicist Koryo Miura.
A combination of parallel and diagonal folds allows the map to be simply squeezed shut.

The Stauche map fold is a flexible design that allows the user to easily select an area
and zoom in on the detail. An overview of the location is shown, divided into four quarters.
By the use of some diagonal folding and cuts, each quarter opens out from the center,
revealing on the overleaf a magnified and more detailed view of the location.

The Turkish map fold is also known as the "pop-out." It also uses diagonal folds to
make the map easy to open up and pack away. Multiple maps folded in this way
can be easily attached back-to-back and stored together. On the following pages
you will find instructions on how to create the Turkish map fold.

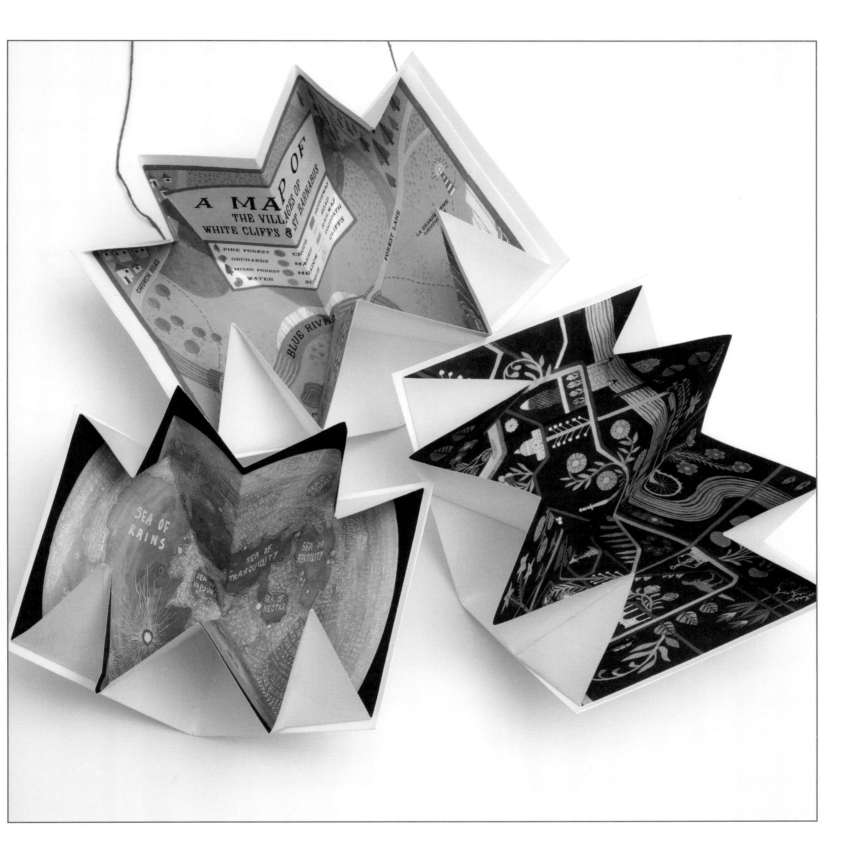

– OVER TO YOU –

1

Place your map on a table with the image side up. Fold it vertically in half. Make sure the fold is good and sharp. Open back out again.

2

Fold one corner to the other diagonally. Make a good sharp fold again. Open back out. Repeat with the other corner to make an X.

3

Turn your map over so the image faces the table. Turn it 90 degrees so that the vertical fold now becomes horizontal.

4

Push the two sides indicated in the diagram gently toward each other so that they fold inward and create a triangle. Make the folds sharp. Lay the triangle down on the table with the base toward you.

5

Take one corner of a triangle from the top layer. Fold it to the center point of the base. Repeat on the other side. Make the folds sharp.

PLEASE NOTE:

These instructions are suitable for a square map and need to be sightly modified for a rectangular shape. You will need:

- Scissors
- Double-sided tape
- A large piece of card
- A ruler
- A pencil
- A square map

6

Open out the last two folds, then fold them back and tuck them in.

7

Turn over and repeat.

When you open up your folded map,
it should look like this.

To protect the map, a cover is attached,
fastened together with string.

To make the cover, measure and cut out a piece of card that is the same height, but double the length, of the folded map. Fold the card down the middle so it opens and closes like a book. Place your folded map, with the point of the triangle in the middle of the centerfold, inside the folded card (see the image on the right). Using double-sided tape, fasten both sides of the folded map to the inside of your cover. Now when you open the card, the map inside should pop out.

The Turkish fold is an impressive way to keep multiple maps in a small space. Tape the back of one map to the front of another, and so forth, to create a beautiful pop-out concertina effect (as seen on the right). You may need to use some ribbon or string to keep the map closed (as seen in the top-right photo).

MARIO ZUCCA

Mario Zucca is a freelance illustrator working in Philadelphia.

Mario has designed custom maps for a variety of clients. His ongoing series of illustrated city maps is a self-initiated project and currently includes four cities—Philadelphia, Pittsburgh, Portland, and Buffalo. Mario's approach to mapmaking is simple: cram as much information into an image as possible. His use of dimensional type and oversized elements, combined with representational landmarks, places his maps somewhere between decorative art and geographical accuracy. You can find more of his work online via his website: www.mariozucca.com.

Q: What is it that you enjoy about creating hand-drawn maps?

I really enjoy the entire process, from the research phase all the way through to applying the final color to a map. I've always had a pretty meticulous drawing style, so doing map work lends itself well to that.

Q: Can you tell us about your *Philly Island* map, shown here?

Philadelphia Magazine approached me with the initial concept to do a map of Pennsylvania with Philadelphia drawn as an island, to accompany an article about how some Philadelphians feel disconnected from the rest of the state. Some of the references, such as "Hunting Camp City" and "Pennsyltucky," were taken directly from the article, but other labels like "Cheesesteak Flats," "Springsteen Island," "Strait of Disinterest," and the intentional inaccuracies were my own additions.

Q: What tips would you give to people interested in creating their own hand-drawn maps?

Try to consider the end goal for your maps. Are they meant to be functional, purely decorative, or somewhere in between? Try to make your maps personal and give them a twist that is uniquely your own.

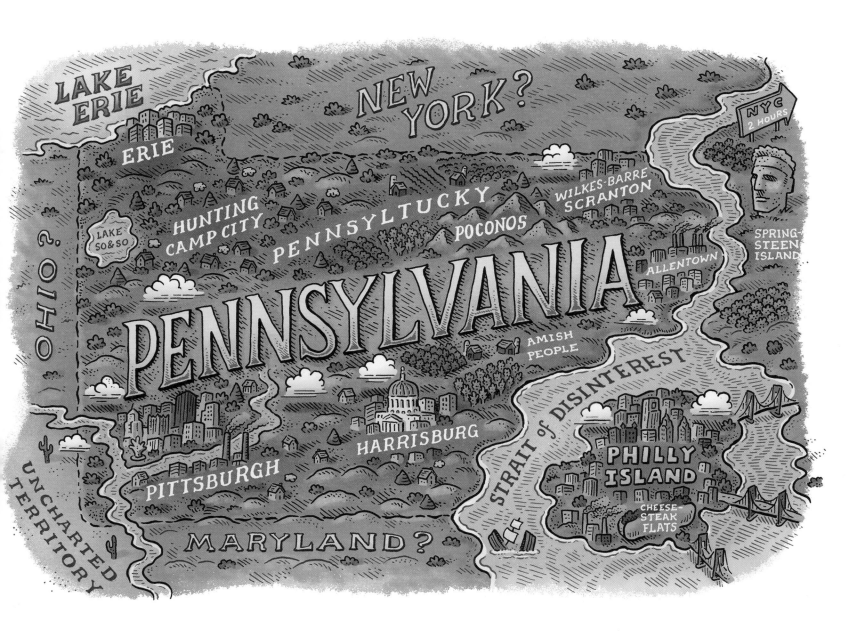

INDEX

A

address cards 144–147, 146
Age of Discovery 9
al-Idrisi, Muhammad 8
alibi_factory 121
Amusement of Him Who Desires to Traverse the Earth, The 8
anatomical maps 104–107, 106–107
annotated maps 80–83, 82–83
architectural maps 56–59, 58–59
artist profiles 36, 64, 92, 128, 156
Asakusa, Tokyo 41, 43
Audiau, Antoine 69
Axis Maps 44
axonometric maps 48–51, 50

B

Babylonia 8, 28
Batman series (DC Comics) 120
Beck, Harry 68
Bolivia 36, 37
Bollmann, Hermann 48
Breitkopf, Johann Gottlob Immanuel 140
Brown, Eliot R. 120
Burwash, Sarah 41
business cards 148–151, 150
Buzan, Tony 108

C

cardinal directions 12
cards 140–151
Caron, Armelle 53
Carta Marina 32
cartography, history of 8–9
cartouches 24–27, 25, 26
Chicago 44
Clemence, Olivia Alice 117
Columbia University Graduate School of Architecture 52

compass roses 12, 13–15, 13
compasses 12–15
Corbineau, Antoine 128–129, 129
Cresques, Abraham 12
cursive lettering 16–19, 17, 18

D

da Vinci, Leonardo 104
Daker, Abi 64–65
Dant, Adam 81
Degraff, Andrew 92–93, 93
design 32–37
Doctor Who 121
dungeon maps 84–87, 85, 87

E

Egypt 8, 76
18th century 9
empty spaces. *See* negative-space maps
equipment 7
Experiments in Motion (Columbia University Graduate School of Architecture) 52

F

family trees 124–127, 126
fiction 120–123
15th century 9
Fisher, Jeffrey 97
folding maps 152–155
France 8, 78

G

Gall, Franz Joseph 96
Gasur, Babylonia 8, 28
genealogy charts 124–127, 126
Geografia di Tolomeo 40
Geographia (Ptolemy) 8
Great Bear tube map 69
Greenland 8

H

history of maps 8–9
Holland 9
Hunter, Linzie 45

I

Inuit maps 8
Islamic maps 8
isometric maps. *See* axonometric maps
Italy 129

J

Jansson, Tove 120
Japan 41, 43
Jeffers, Oliver 97
Jerusalem 8

K

Kani, Hiroaki 113
Kellogg, D. W. 140
Kendall Refining Company 25
keys 28–31, 30–31
Known Unknowns (Fisher) 97

L

La Paz, Bolivia 36, 37
Lacoste, Eugène 101
Lee, Hyesu 112
lettering 16–23, 17, 18, 21, 22
L'Isle, Guillaume de 25
Lloyd, Bryan 44
London 68, 72, 73
London Underground 68

M

magnetic field 12
Magnus, Olaus 32
Mao Kun Map (Pirates of the Caribbean) 88
map folding 152–155
McLean, Kate 116–117
Mercator, Gerardus 9
Mercator projection 9
Middle Ages 8
Middle-earth (Tolkien) 120
Milan, Italy 129
mind maps 108–111, 109, 110
monasteries 8
Moominvalley (Jansson) 120
Mora, Elsa 109
movies 88, 120–123, 121, 122

N

nationalities 112
neatlines 32, 35
negative-space maps 52–55, 54
Netherlands 9
new address cards 144–147, 146
19th century 9
Nordic countries 32
Nuzi, Babylonia 8, 28

O

Ogilby, John 6, 77
Ordnance Survey (OS) 28

P

Pac-Man 60, 61
palmistry maps 100–103, 101, 102
parallel perspective 48
Paris, France 78
Paris, Matthew 76

Partial Map of Your TARDIS (Subject to Change), A 121
Patterson, Simon 69
people 112–115, 114
personal experiences 80
phrenology maps 96–99, 98
picture maps 40–43, 43
Pirates of the Caribbean 88
platform-game maps 60–63, 61, 62
Polynesian maps 8
Ptolemy 8, 40

R

Renaissance period 8, 40
ribbon maps 76–79, 78
Robert, Liam 72, 73

S

sans serif lettering 20–23, 21, 22
sensory maps 116–119, 117, 118
serif lettering 16
16th century 9
smell data 116–117
Smith, Keri 101
Speed, John 6
Stevenson, Robert Louis 88
Stone Age 8
Stone, Joe 124
subway maps 68–71, 70
Super Mario 60, 61
symbols 28–31, 30–31

T

text maps 44–47, 46
3-D maps 9, 48
Tilly 36
Tokyo, Japan 41, 43
Tolkien, J. R. R. 33, 120

tools 7
transit maps 68–71, 70
travel journals 136–137, 138–139
treasure maps 88–91, 90–91
tree maps 72–75, 74
Tree of Brixton Pubs and Cafés 72, 73
true north 12
20th century 9
21st century 9

U

underground maps 68–71, 70
Utagawa Kunisada 105

V

Valentine's Day cards 140–143, 142
Villages of White Cliffs & St. Barnabas (map) 34
Vinci, Leonardo da 104

W

Warosz, Manuel 69
wedding maps 132–135, 134
Wheeler, J. R. 73
Wickedest Place in the USA, The (Lloyd) 44

X

XKCD webcomic 121

Y

Yoshida, Hatsusaburo 48

Z

Zucca, Mario 156–157

ABOUT THE AUTHOR:
HELEN CANN

Helen Cann is an award-winning illustrator and artist whose current studio is in the seaside town of Brighton in southern England.

Her work has been published in more than 30 books and exhibited worldwide. In the past few years her fine art practice, principally mapmaking, has gained increasing recognition and gallery exposure.

Fascinated by folklore, history, and personal anecdote, Helen is interested in how people understand their location through maps by associating them with stories of themselves and others. In her own work she weaves stories together to map a multilayered view of places that incorporates the physical, geographical attributes.

The inspiration for her maps is often sparked by her own travels and she has made several expeditions: dog sledding above the Arctic Circle, sleeping in an igloo, drinking reindeer blood with Sami herders, and sailing across the North Atlantic tracking whales.

Her work can be seen online at www.helencann.co.uk and www.helencannfineart.co.uk

ACKNOWLEDGMENTS

Helen wishes to thank James Green for the advice on Dungeons and Dragons.

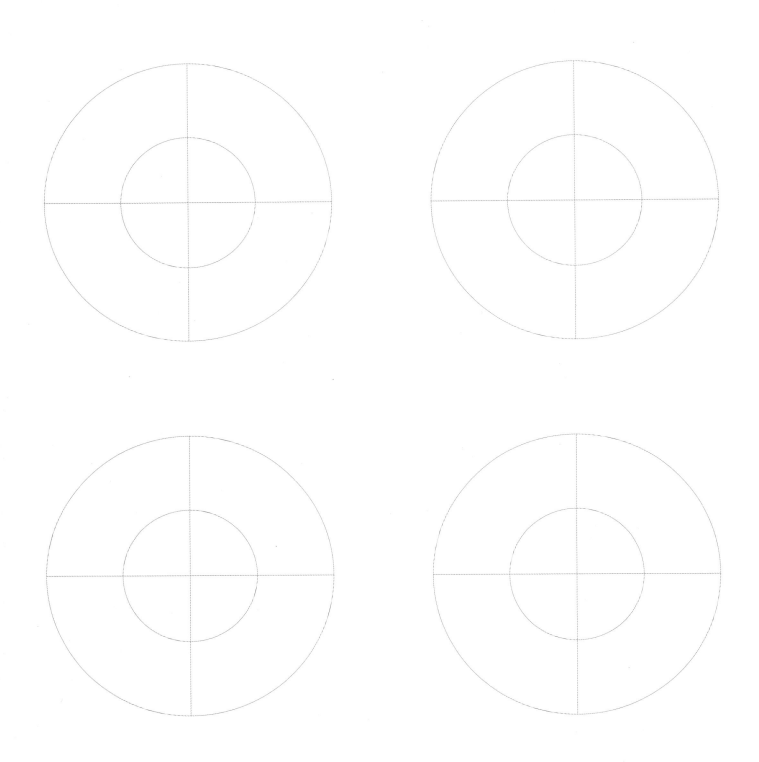

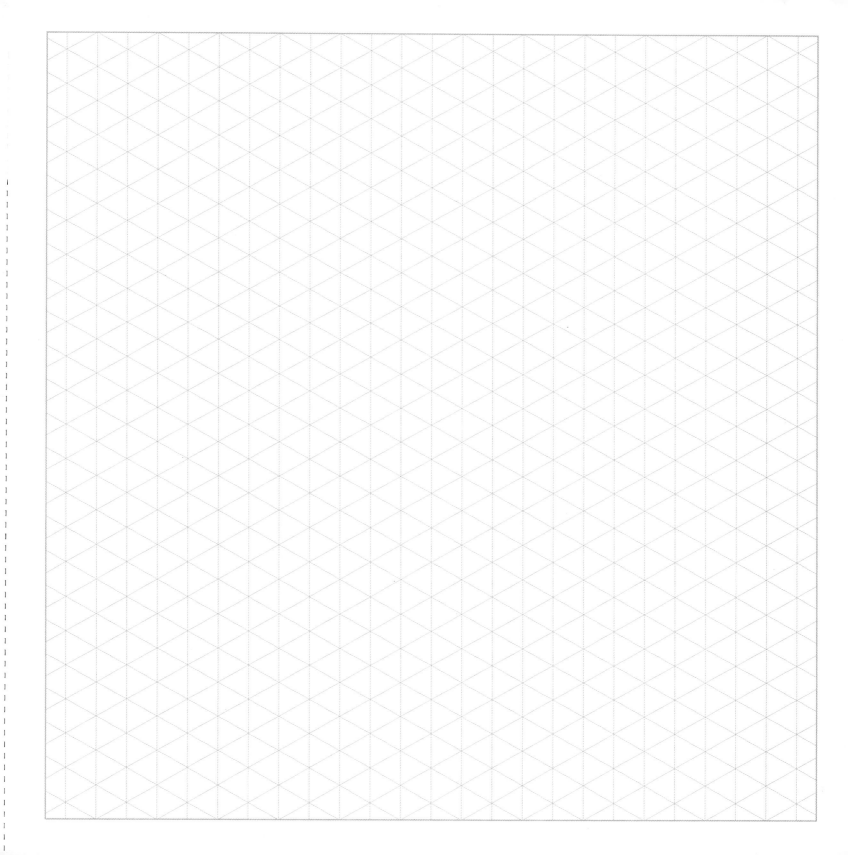